Miss O'Keeffe

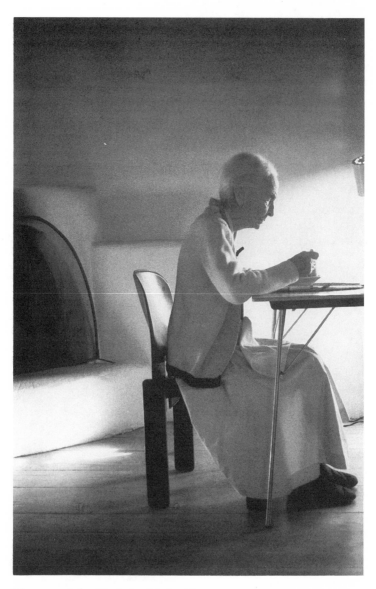

Photograph by Christine Taylor Patten

Miss O'Keeffe

Christine Taylor Patten

and Alvaro Cardona-Hine

UNIVERSITY OF NEW MEXICO PRESS

Albuquerque

Library of Congress Cataloging-in-Publication Data

Patten, Christine Taylor, 1940–
Miss O'Keeffe / Christine Taylor Patten and Alvaro
Cardona-Hine.—IST ed.
p. cm.
ISBN 0-8263-1322-1(cloth) 0-8263-1961-0 (pbk.)
I. O'Keeffe, Georgia, 1887–1986. 2. Painters—
United States—Biography. I. Cardona-Hine, Alvaro.
II. Title.
ND237.05P37 1992
759.13—dc20
[B]
91-22431
CIP

To my friend, Jeanne Hughes Beley,
who died too young, and whose illness,
and my inability to take care of her,
helped me to comprehend the privilege it is
to take care of anyone.

C. T. P.

Acknowledgments

I give thanks to Philip L. Shultz, M.D., for his loving doctoring of injured eagles and other raptors; to Kay Harvey for extraordinary friendship; to Catherine and Lawrence Piersol for their propitious encouragement; to Carol Bly for her courageous words; to Tadeusz Debski for his wisdom; to Catherine Taylor Curtis for filling in the blanks with wit; to Barbara McCauley Cardona for her exuberance and energy; to Maggie Magee for her presence and serenity; to Dan Younger for making visual sense of my amateur photography; to Rob Silberman, for his brilliance; to my husband, Gendron Jensen, a gentle man; to my sons, Robert, Jonathan, Matthew, and Michael Powell, nurturing men who keep reminding me how to love; and to my friend Carol Sarkisian and all the other women who cared for Georgia O'Keeffe.

C. T. P.

Miss O'Keeffe

Preface

This book is a recollection and an examination. In part it is a portrait of a woman who gave America and the world a way of seeing through a woman's eyes, a portrait of that woman as she was at age ninety-six, too blind to work, weak enough to need assistance, lonely and confused. She found the companion she needed in Christine Taylor Patten for the year they were together. The book is also, inevitably, a portrait of Christine.

I met Christine in 1987, and one evening at her studio, talking about this and that over dinner, she spoke of having been one of Georgia O'Keeffe's companions—or nurses, as they were called. The matter came up round-about and she was very reticent about going into much detail. It was at my urging that she told me how she had cared for the famous woman for almost a year, beginning in 1983. How fascinating, I re-

member thinking: a female artist taking care of another one. Assuming that Christine had a great deal to tell about O'Keeffe's opinions and ideas on art, I kept firing question after question at her. To my surprise, it was the human story that grew larger than life, full of warmly remembered detail and love for the nonagenarian.

A problem emerged almost from the beginning: Christine's reticence. This reticence was due to her natural instinct to protect O'Keeffe from mere curiosity and because, as I was to find out, she knew so much about what had transpired during those days when O'Keeffe was finally transferred from her beloved Abiquiu house to a noise-ridden mansion in Santa Fe. It had not taken her long to become attached to O'Keeffe, to discover the real woman behind the myths as prevalent then as now, and to learn to serve her. She had to deal with the real Juan Hamilton, and observed his volatile ways, so she had formed the prudent habit of keeping the story of her days with O'Keeffe much to herself.

That night, on my way home, I thought the world needed to know the story, and I made up my mind to approach Christine as soon as possible with the suggestion that we write an account of it in a collaborative fashion. She would write down everything she remembered, or put it down on tape, and I would transcribe

the material, write the account of it and present it to a publisher.

For me, it has been a privilege to listen to Christine and record her story. It is her story. I quickly discovered that she wrote with an eloquent sense of style. It dawned on me early that I could not drown this voice in an attempt to turn out a standard biographical piece.

From the first, when I did talk to Christine, she insisted that such a book, if at all conceivable, would have to leave aside all manner of things about O'Keeffe she deemed too personal, and anything damaging to those still living. It could not be an exposé or dwell on sensationalism. Regarding Hamilton, she was most explicit; she wanted nothing in the book beyond material necessary to round out the story. I am in complete agreement with this.

The value of this book will be for those many, many people in all lands for whom Georgia O'Keeffe is important not only as an artist, but as a human being endowed with profound grace and dignity.

Then too, for me, from the first, it was a question of presenting what was of supreme importance in the story: the relationship that grew from employer-employee necessities—from a mere job to help make ends meet as far as Christine was concerned, and from

the very real needs that O'Keeffe had at the time for a companion—to that of a friendship based on mutual respect and understanding as the two women discovered one another's affinities and depths.

I feel that the use of two voices, mine and Christine's, allows a portrait of the younger woman to emerge. In the end, the reader can see that the spirit of O'Keeffe suffuses everything, as does the bandaging love of the younger woman for her charge. This caring is everything. All else is circumstantial detail mirroring, as life always mirrors, the true natures of individuals involved in their daily lives, in all of their pursuits and schemes.

Hamilton once told Christine that what he wanted was to be recognized as being of more importance in O'Keeffe's life than Stieglitz. One is reminded of Goethe's dictum that nothing is worse than ignorance in action.

Again, that is not the story. It's an aside or, let's say, the bit of darkness posited outside so that the light shining in that little Abiquiu bedroom could shine with actual fervor; that light that, once Georgia was asleep, Christine would come and put out, tiptoeing in from the studio where she would work the night on one of her own resplendent drawings.

A.C.H.

Introduction

Georgia O'Keeffe was one of the ways to be a woman and an artist, and it seems important not to see her life as a mold, a pattern that determines form, defining a way to live. The circumstances of her life are not the example. It is the abstracting—as with the flowers, bones, the simplicity—that should be the example, the abstract continuity of unseen patterns and clues, culled in perhaps unrecognizable form at first, but revealing, when examined, a simple clarity, wholeness.

Her example is as simple as the evidence: it is that she cared intensely about what she did each moment and, most important, that she allowed that caring to show. It was this elemental human quality in Miss O'Keeffe that provided power and intensity, and gave her life definition. She didn't feel a need to apologize for that caring by hiding it, or by pretending that "getting it right" didn't matter, or by being indifferent, detached, about what she was doing.

I was one of a long continuum of women who took care

Miss O'Keeffe

of Georgia O''Keeffe at different times in her life, in different capacities. Much of this story could be told by any of these women, each in her own way. Late in Miss O'Keeffe's life, we were attending to her simplest needs, and the truth is, it was she who taught us about caring.

People reveal themselves in small ways, in fleeting, candid, incidental words and gestures. An act as plain as slowly, deliberately lifting a teacup to one's lips, or perhaps inquiring gently of another's well-being, not bringing attention to oneself—that is what I saw. And that is what this story is about. She allowed us to see a life of careful attention, and it was clear.

Georgia O'Keeffe is an example to us that we can be independent, powerful and caring, that those can be one and the same; and that in the consummate act of harmonizing with nature's ways, in its deceptively contradictory forms, we are strengthened, and rather than lose identity, find it.

C.T.P.

Die Rose ist ohne warum;
sie blühet weil sie blühet.

The rose without a why
flowers because it flowers.

ANGELUS SILESIUS

One

It is a Wednesday in October, and it is 1983. She has driven up from Santa Fe, for an interview, nothing more.

Jan Ohrbom, a friend from college days, had been taking care of Georgia O'Keeffe on weekends and couldn't do it any more. She had given Juan Hamilton Christine's name. He called and asked, Would she go to Abiquiu to talk to his secretary and meet O'Keeffe?

She left her studio near the railway tracks, and drove up St. Francis, the impudent beauty of the Sangre de Cristo Mountains facing her. She passed the military cemetery off Paseo de Peralta, with its rows of perfectly aligned graves. The car climbed away from Santa Fe. At the top of the hill, the northern suburbs spread out before her, with the Sangres now to her right.

She coasted down the two long hills, past the entrance to the Santa Fe Opera, and was swallowed by the

piñon- and juniper-studded valleys that led to Española, a land of red soil with its hills eroded by rain.

Already, in her heart, she knew she would be offered the job, and that she would take it. The feeling excited her, but then she grew apprehensive. She took a deep breath and tried to shrug the feeling off. She knew herself to be shy, but everyone is a bit nervous in the face of an unfamiliar situation.

The further from Santa Fe she got, the more she realized what was at the center of her nervousness. It was the legend. Not just that this was one of the most famous women in America; the beloved, independent woman. It was the other things. O'Keeffe was usually described as a tough customer, haughty, imperious, brooking no nonsense. Christine felt intimidated as she thought about the person she was going to meet.

She passed through Española. When she left the town behind her, the landscape asserted itself once again. It was a half hour of more constricted, drier terrain, with the distant mountains framing the day.

Abiquiu is on the left side of the road, up on a hill. Christine drove up the hill, very consciously changing gears, slowing down to look. She wasn't sure she'd find the place and wished she had gotten clearer directions.

Miss O'Keeffe

She paused at the top. It couldn't be the big house on the left; she wanted it more remote, more forbidding, more like the image she had of Ghost Ranch—in the middle of nowhere.

She drove around the property stubbornly seeking something concrete that would shout O'Keeffe's name to the world. Nothing did. It was a large and handsome enough place from the outside, but, to Christine, it didn't feel right yet.

When she spotted two men digging in the yard behind a fence, she stopped, rolled down her window, and called out. It was Miss O'Keeffe's house, yes . . . If she went over there, she'd find the main gate open . . .

The driveway only led to another gate. She was aware of three things: that the noise of tires crushing gravel had stopped because she had come to a halt, that her heart was beating with extraordinary force, and that a young woman had appeared and had opened a second gate.

This was Pita Lopez. It wouldn't take long for Christine to appreciate this woman, who functioned in several capacities. She lived in Abiquiu and was the daughter of Candelaria, the regular cook. A tall, gentle, dark-haired woman probably in her twenties, Pita was

devoted and responsible. She was effective and reliable, with a wry sense of humor and a ready smile. She seemed to take things in stride.

Pita led Christine into the studio. Christine was surprised by the ordinariness of the big room. Since it was no longer used as a studio but as a general office it had been carpeted and contained some uninteresting furniture.

Christine followed her guide across the room through a bathroom to the bedroom. Another shock. An old, diminutive woman was sitting on a low chair in a corner. Christine saw that she was wearing a black, kimono-style dress over a white underdress. Her hair was pulled back in a bun. It was braided and then twisted into a bun back of her head where it was held by combs.

Now that Pita addressed O'Keeffe, Christine noticed that she raised her voice substantially. "Miss O'Keeffe, this is Christine. She might be your new nurse on the weekend . . ."

The frail person in the muted light leaned forward and turned to face her visitor. Her left hand rose from her lap and reached out in a hesitating gesture, as if in that way she could focus her eyes where they were needed. Her brow furrowed questioningly.

"Will you take care of me this weekend? There's no

one to take care of me this weekend," she said in the small, scratchy voice of someone who has reached the age of ninety-six.

The prospect of the job suddenly filled Christine with apprehension. She hadn't been prepared, hadn't expected this helplessness.

But she smiled. She still wanted to do it, to try. "Perhaps, Miss O'Keeffe; we'll see. I am glad to meet you." What she really needed to know was what was expected of her, what would be demanded.

She heard Pita telling O'Keeffe that she was a mother with four sons. That she was an artist.

"Well, isn't that fine," the frail woman commented. Then she repeated her concern in a tiny, slow voice, like a child begging for the childishly essential. "Will you take care of me this weekend?"

Pita told her that she was going to show Christine around the place and that they would discuss the matter. As she left, Christine noticed the corner fireplace glowing with the embers of what had been the breakfast fire. For the first time, in a strange and heartwarming way, Christine caught a sense of strength from the room, a solidity that would eventually reveal a still resourceful woman. The plaintive voice, the appeal, had sprung from momentary circumstances. There was

more to O'Keeffe than most humans exhibit in the prime of their lives.

While Christine and Pita were in the room with O'Keeffe, nothing was said about what Christine was supposed to do. Once out of the room Pita asked, "Well, do you want the job?"

Christine could only reply, "Why don't you show me what is entailed, give me a tour and everything, and let me see."

Pita gave her a tour of the house. The studio and O'Keeffe's bedroom were apart from the house; they were a separate building overlooking the highway and the farmland beyond it. Across a courtyard were two other buildings connected by a portico. Pita took Christine to what was the main house. This was the original adobe structure standing when O'Keeffe had purchased the property. There was an inner courtyard with a black door that she had painted once upon a time.

The pantry in the main house was a very appealing room with a real sense of domesticity about it. Pots and pans hung from the walls. The kitchen was very simple with an old stove, nothing fancy. Pita told her it didn't work very well and showed her how to light it. There was a dishwasher by the sink, but it had not worked for some time. Then there was a mangle with

which to iron sheets. The table was a mere plank held up by something close to sawhorses but more sturdy than that; there were chairs on one side of it. Christine noticed that it had been painted, or rubbed with white paint to tone down the color of the wood. The paint had been rubbed off so the surface of the table had a shiny patina, as if from years and years of use.

The whole place had the piney smell of *piñon* wood, especially in the studio and bedroom, where the wonderful odor was quite pungent, perhaps because there had been so many fires lit for O'Keeffe's benefit during the years.

Pita's presence, her intelligence and charm as she showed Christine around the place, made Christine lose any forebodings she may have had. Pita asked her again if she wanted the job. It felt right. Without discussing many details, Christine promised to come that Friday. All in all, she hadn't been there more than half an hour.

No sooner had she left, of course, than a thousand questions popped into her mind. She had cared for a family, was raising four sons, but she had never been in charge of anybody who could be even remotely defined as elderly. She went to Jan's old adobe along the highway in Abiquiu. They sat at her kitchen table near the wood stove and talked for a few hours. They discussed

the routines at Abiquiu, the daily rituals in O'Keeffe's life, how to do things, where things were kept, what to avoid, what to look for, what O'Keeffe was to eat.

Now that she was supplied with a few facts one set of Christine's questions left her and another took its place. A dozen times each day she'd ask herself what she would do if there were an emergency. O'Keeffe seemed so feeble, she would have to be handled almost as a breakable object. And what would a day, consisting as it does of a multitude of unending hours, be like? She was to be there from Friday afternoon on. Was it possible that the time would pass or would the world grind to a standstill while she stood, hands glued to the back of a wheelchair on which the most formidable and most formidably ancient woman in America sat gazing at the point in space through which her childhood and her youth, her Stieglitz years and watercolor ways had fled?

Christine had sensed, no matter her present frailty, that Georgia O'Keeffe carried within her the essence of all she had manifested in art. It was a muted force, evident in her carriage, her voice, her clothes, her house. Her eyes were no longer able to be used but everything else on either side of those vague lenses was still there: the two environments, one the wild New Mexico she loved and the other, the human assessor of it, were still

intact, perhaps in closer contact now that stillness was upon her.

To take care of this woman would be to take care of herself, to breathe the fresh air that had stirred those giant flower petals O'Keeffe had painted, those canyons and airborne bones heralding a new feminine consciousness almost as obviously as if O'Keeffe had painted new and powerful women. She would be taking care of a being who had presided over the structuring of light. Her possessions, the most humble of them, would lend her their candor.

Two

I was petrified because Jan Ohrbom had told me O'Keeffe was very strident and very meticulous about the way she wanted things done. I wasn't to make mistakes. So I was very nervous. I didn't know how to speak to her, didn't know how well she could hear, didn't know how she would respond.

I was led to believe she didn't hear very well so one would have to speak very loudly. In order to read to her one had to get close. But how close?

A number of people had warned me that the job I had taken was not an easy one. The first couple of weekends were harried because I didn't know what I was doing. She was used to having things done in a very particular way. Everything was very exact. In her bathroom she would sit in a chair to get ready for bed. There was a specific place to put her slip when I took it off. Her stockings went in a certain place and her gloves went in a certain place. Temporary places were also very specific: if you put down the hairbrush, it was to go in

a particular spot. I had been warned. Jan Ohrbom had told me. And I could understand why that had to be; that was her way to have some security since she was nearly blind.

But there was much I wasn't told and I didn't understand O'Keeffe's explanations. For instance, when I would brush her hair, she'd sometimes shout at me. I had no idea how I was supposed to brush it. It turned out that there was a very specific way. "You turn the hair brush!" O'Keeffe said.

"How do you mean?" I asked.

She answered impatiently, "Oh, what do you mean, how do you mean? You turn it, that's what I mean!"

She wanted the brush flipped and pressed down hard. If startled by something I did wrong she would lean forward, her head would bend down and she'd scream, "No! Don't hurt me! You fool! Don't you know how to brush hair? Hasn't anyone taught you how to brush hair?"

She was very sharp while I was learning. The thought occurred to me more than once that she was testing my endurance. Pita finally showed me how. I hadn't been pressing the brush down firmly enough. It must have been very difficult for Miss O'Keeffe to have a new nurse when she was as helpless as she was. Her hair was braided and the braid wound into a bun. Some inexpensive silver-colored combs were used to hold the bun in place and larger, nicer ones were used on the sides of her

head to keep the hair off her ears. She loved to have her hair brushed. She loved the feeling of very firm strokes on her scalp, yet she would shout if there was any tangling or pulling of her hair. It was a difficult job, for her hair was quite long and would have tangles in it since it had been braided all day or overnight.

The ritual of brushing her hair was done twice a day: first thing in the morning, and at night. I would take the braid out of her hair and brush the loose hair thoroughly, then braid it again for nighttime. It would be left in a loose braid down her back, for the night. Occasionally, I would leave the braid loose in the day. She didn't care if it was loose or wound up in a bun.

I once overheard her telling a friend on the phone, "My hair has turned white, but I guess it really doesn't matter. I can't see it, but I reach up and feel it, and it feels pretty lively. They tell me I look good, like I have no right to look good. Everyone's mad at me. I am a hundred and seven, I think. But, anyway, I have three more years until I'm a hundred."

She used no perfume or powder, but only natural, sensible products like oils and cream on her face. She loved to have cream on her skin. She would remark about her skin feeling dry and wanted her hands rubbed with cream and massaged. She would then put her white cotton gloves on. She liked to

wear the gloves to bed at night with lotion on her hands to keep them from getting callouses, to keep her hands soft. She once recommended that I do the same. I had told her how I admired her hands. She took hold of mine and said, laughing, "Well, you know how I do it!"

Her skin. It's hard to talk about it on purpose. I remember one time when I had been bathing her and looked at her back. Her bones were exquisite. Her body was still very shapely and feminine. While I had always thought old people beautiful to look at, I had not necessarily expected an old body to be so. I had never had such close contact with an elderly person and was surprised. Gravity had taken its toll but her body was still lithe. The folds of skin on her back were so graceful, like velvet draped on her exquisite frame.

One of the things that was important for me was this look of her back, this amazing beauty, probably because it was symbolic of her dignity. The way her flesh hung on her back like silk or satin curtains . . . perhaps it was that she had particularly beautiful bones, as anyone who has seen Stieglitz's photographs of her can attest. I do not wish to invade her privacy but it was so beautiful, it said so much about her because, of course, it involved the dignity of her carriage.

One of the things that O'Keeffe was about was that kind of beauty in a woman. Women in their nineties allowed to be

beautiful . . . her beauty was understandable to the people around her, it was accepted without question.

The way she moved is indelible in my mind. Everything about her was congruent. The way her body was and the way she moved, the way she thought, even the way she spoke were all in harmony with each other. I observed no conflicts in her being. Everything made sense, everything was part of a whole that was undeniable. Her demeanor was like her body: there were no contradictions.

Her eyes were fading away. They were greyish, colorless. Both my friend Carol Sarkisian, another artist who nursed O'Keeffe, and I remember them as being grey-blue eyes. They would be glazed much of the time; she would look out as though blind, but then she would see light or movement. She could see my kimono at night. She would see that the curtains had not been pulled tight and say, "No, pull them more."

At times she would just stare. If you were to walk into the room she was in and speak to her, it was obvious that she could not see for sure, that she could not capture detail. She would not look you in the eye at all, she would only look in your direction. There was expression there, but it was the expression of an old, blinded person. It was her mouth, her smile, that enlivened her face. Her face would mold completely to its patterns. She smiled often, and giggled and laughed.

Miss O'Keeffe

*But about her eyes one would have to say that she had
shadow sight. And I think that in a sense this freed her into
an even more simplified and matter-of-fact existence. She had
the guts to tell me later, "These sightless years are a minor
part of my life."*

*The first month I was not at ease and that probably led
to her unease. I was afraid to make a mistake or hurt her.
I wasn't comfortable leaving her in the studio in order to go
to the kitchen. Many things necessitated leaving her alone. If
I were gone too long, in the beginning, she would get herself
over to the sliding door, open it, and blow her silver whistle.
Even if I were only gone five minutes, since her sense of time
was not good at all, she'd ask, "What's taking you so long?"
or, "What are you doing in the kitchen?" I'd explain that I
was doing such and such and she would be mollified and say,
"Yes, go back. Go do what you need to do."*

*She'd be very sweet at such times so my feeling was that she
just wanted to get things clear. She was never unnecessarily
rude. She was not lashing out or trying to impose her superi-
ority on anyone. I felt that her agitation had a real reason.
She genuinely wanted to know why I wasn't there in the studio
with her because she didn't grasp that I had only been gone
five minutes. And when I would bring her the meal she would
be so grateful. She'd say, "You've gone to so much trouble, this
is wonderful!" Or she'd remark on a particular flavor which*

was pleasing to her, one she was able to discern. She didn't seem to have a very sensitive palate at that point.

Things were sorting themselves out. For instance, I discovered that I did not have to get close to her ear in order to read to her. I found that my voice could come across when I sat next to her. We had no problem with conversation.

O'Keeffe did not seem egocentric to me. There was, in the fall of 1983 and winter of 1984, a clarity of experience, a directness not only in her speech but in her acts that seemed to surpass her ego. While she would want her own direct needs met, she never failed to consider my own as well. She'd say, "Are you sure you have had enough to eat?" "Did you manage to sleep well?" And she consistently thanked me for even the smallest gesture, thanked me for so often wearing my purple flowered kimono because she could see enough of it at night: "It's a treat to my eyes to see such a handsome garment indeed!" That was how she would identify that it was I in the middle of the night.

Her directness—"Give me a handkerchief," "Take me to the bathroom," etc.—was just that, a direct statement of what had to be. It wasn't to be erroneously interpreted as orders. This was evidenced over and over in my experience by her responses to an explanation; for example, why something wasn't necessary, or that she already had a handkerchief in her hand. She would laugh, not be upset at her "loss of face," as she

might have been if she were throwing her weight around. Or I'd say, "You just had lunch, Miss O'Keeffe. Are you sure you are hungry?" And she'd reply, "Well, of course, you are right," or, "Oh, my dear, I have forgotten."

These observations of her intent, of her simple, clear, direct approach to everything, made me wonder if she had not often been misunderstood. Her directness may have been interpreted as overbearing and difficult because of her reputation for being demanding. Never once was her behavior incongruent or unrelated to real situations. It was never unreasonable. Her irascibility was directly related to specific circumstances. If one paid attention to how she wanted things done, there was no problem. Routines gave her a sense of continuity and control, so once I understood them she was very calm, essentially very calm the rest of the time I took care of her.

She made comments which were meaningful only to herself. There was obviously an internal dialogue going on as well as some lack of logic. She wasn't reasoning in a deep, analytical way; on the contrary, she dealt with things at a rather simple level. Like many old people, she would repeat herself. She spoke very slowly, haltingly, at times. Some days she was more fluid. She had a soft voice; it was very small and she seemed distant a lot of the time.

She rarely talked about art and she wasn't analytical about it. For instance, we spoke of Arthur Dove one time. Her face

Miss O'Keeffe

lit up when I mentioned his name. "Oh yes, I remember he made beautiful paintings. I remember those paintings. He was a very sweet man. I liked him very much." She would comment that he had wonderful paintings, but she didn't talk about their content.

Three

Christine had recently turned forty-three when she first went to work for O'Keeffe in Abiquiu. She was—is— less tall than the average Anglo woman, and there is something Welsh about her good looks, although her mother is Irish. She has warm brown eyes clearly set in a fine open face, regular features perennially lit from within by a friendly and generous nature. Her jaw implies determination. In fact, it was praised by O'Keeffe. One time O'Keeffe touched her face to know her better and said, "You have a very strong jaw!" They had been sitting in front of the fireplace in the studio on a cold day in late November. They were talking about facial structure. Suddenly O'Keeffe asked, "May I feel the bones in your face?" And she felt Christine, then she laughed.

Christine was born in Los Angeles, married there and later moved to New Mexico. After she divorced,

she took over the family ice cream business, a congenial place where her four sons could also work and the family could spend more time together.

She had dreams. She was passionate about her art and determined to pursue it in spite of all difficulties. She had heard professors at Otis Art Institute maintain that only ten percent of the students attending the school would end up as artists practicing their craft. She knew she would be in that ten percent.

She would often get up at four in the morning and draw. The town would still be asleep, and she could hear the first stirrings of her brood, as she worked with pen and paper.

Her schooling had taken place everywhere: high school in California and Germany, where work had drawn the family; then studies at the University of Oregon, Pasadena City College and, eventually, graduation from Otis Art Institute.

In Abiquiu, at the expense of the few hours she could have slept, given O'Keeffe's needs, she chose to stay up and draw in the studio much of the night.

This was every other weekend at first. Then she started filling in for the person who was working the other weekend. Things changed, and soon Christine was working just about every weekend; she'd arrive

on Friday afternoon and leave Sunday evening or Monday morning, depending on when the next person was scheduled to arrive. When she was there, she was responsible for O'Keeffe twenty-four hours a day.

February of 1983 had been a turning point for Christine. She had been struggling, trying to make decisions about her art, the family's living situation, and whether or not to keep the business. On a trip to California to take a breather, she wandered into Lacy Park in San Marino, where she had spent time as a child and where she had so often taken her own children to play when they were small. She lay down under a magnolia tree in bloom, thinking about life and what to do about it. Unhappy, she lay under the tree, spread-eagled, her palms upward on the cool grass.

At that moment, a petal from a magnolia blossom fell down from the tree and landed in her right hand. She resolved that by the end of that year she would not be running the business anymore. She would spend her time doing her drawings no matter what, to the extent that was possible at the beginning.

On New Year's Eve 1983, she walked through the empty and by-then-sold establishment where she and her children had worked so hard, no longer cursing the compressor which had failed her twelve times. She

closed the storeroom where so many happy and not-so-happy times had occurred, where inventories had risen and fallen, where so many decisions had been made, where friendships had been formed that would last a lifetime. She carried a lighted candle through that store letting the light rest where it would, on the details of darkness that would now begin to fade, and said goodbye to it that way.

She remembers that, as a child not yet six, she had lain in the deep grass of the backyard, daydreaming, her hand making patterns in the sandy soil. The natural movement of her hand had made a curved line in the soil, and it resembled one of the long blades of grass near her. With a flash of awareness, Christine realized that she had stumbled upon a great secret of the world: the correspondence between things.

There was Europe, when her father was working there, and there was Pasadena and summers at the beach in Del Mar, where her beloved grandfather lived. He had been a drafting teacher and had retired early spending most of his mature and asthmatic years gardening in what was then a peaceful beach town. She remembered vividly his cigar smells, the wheezing, his orderly garage, the bunk beds for his grandchildren's summer visits, the clean smell of the guest bathroom

after a sticky day, hearing the crickets at night, the banana and avocado trees. He had an old Chevrolet which he would drive a hundred miles to go and visit the family in Pasadena a couple of times a year. At Christmas, he'd send ahead large boxes filled with toys and presents for the five children and the parents.

When Christine left the University of Oregon and took a secretarial job, he sent her a severe letter telling her that she had a responsibility to the arts, that while she could feel important being a secretary, she must draw. That letter made her go back to school later, when she was thirty-one years old.

She has this vivid image of him standing in the kitchen, pounding his cane on the floor, dressed elegantly in a grey wool suit, perfectly tailored, with thick glasses so fuzzy one couldn't see the beautiful blue of his eyes anymore, and saying he knew he was going to die, and didn't want to.

Four

At first I was going to Abiquiu only every other weekend and then she asked me if I would come every weekend. She said that many times the nurses wouldn't come when she blew her whistle. "Sometimes I have to get my coat myself and go over to the kitchen to get them. You pay more attention to me."

There was in me a desire to be receptive, to learn, to be in a state wherein I would see and understand. To make sure that I didn't imagine her needs but to hear those which were real, to be the receiver of the music, the observer of the painting, for that which was received was the experience. David Schnabel, a great teacher of mine, once taught me to be present and fully receptive, from teacher to teacher, in order that each perspective be experienced without qualifying or judging. With this attitude one learned a way to accept a situation unconditionally in order to learn from it, in order that one might learn to see. The experience with Miss O'Keeffe was like encountering

a mysterious painting and, curious, placing oneself in a state of complete acquiescence in order to begin to receive what was being communicated. I say "begin" because this was, indeed, only a glimpse of the spiritual, a glimpse of that which is always changing.

For fifteen years or more, my life has been involved with observing the differences between movement and stillness, with the tensions and easings, if one may put it that way, between those two different aspects of life. And in my opinion, it is a mistake to think of them as opposites. Stillness is not simply the absence of motion—it is dependent, indeed, upon motion. If the motion is not well-defined, a still point does not exist. It was from this perspective that O'Keeffe's ways intrigued me. I watched to see in what way the movements of her living accumulated into stillness, revealing that balance-of-all-motion that seemed still.

I watched small motions, physical motions, a consistency of form and flow, uninterrupted by hesitancy; the movement of her hand congruent with a pause in her speech and a pause for breath, for instance. Or a thoughtful gesture balancing or juxtaposing a shift of her body from an uncomfortable position and revealing her grace. The stillness was a resonance, as if her existence were that of a fine musical instrument, the rhythms of its music ever changing within an exquisitely sensible whole . . . a violoncello perhaps, suggesting, reveal-

ing the resonance of the planets, the coherence of molecules, the stunning, quiet swiftness of light.

She had gestures, mannerisms, all her own. I remember her drawing her hand, with middle finger dominant, down along the side of her nose, barely touching her face, very elegantly, as though she were a queen at court.

She would smooth the lapels of her dress. She would smooth the fabric on her skirt. She had the habit of moving her hand very slowly over her lap, smoothing the fabric down over her knees. This was not the action of a neurotic old lady making sure her legs were covered, it was just a gesture, perhaps even a way to feel the fabric, a sensual act.

Often, she would be sitting on a chair or on the couch and her hands would be folded in her lap. Then, with the fingers of one hand, she would take hold of the white line of fabric that was peeking out from her other sleeve and straighten it out, tug at it a little bit. It was done very slowly and as though she were feeling the curve of the outside edge for the first time.

And with her middle finger she would touch and pull back the hair over her ears in a gesture going from the front to the back of her head. She'd try to pat the hair down above her neck in back, hair that had come loose from the comb holding things in place, or hair that she simply imagined loose.

As she would doze in her chair, the expression on her face would be grumpy sometimes, and there would be a frown on

her face. Her head would sink slightly although her basic posture would remain erect. Or else her face would soften a little and her lower lip would protrude more than at other times. When she was sleeping, her mouth might be slightly open, the skin on her face would fall back and be smooth, translucent, paper-thin, and she would look skeletal, the skin was pulled so taut over her face. Her face was full of lines normally, so there was a difference.

Looking back, I see that my absorbing her tempo was a joining with her own sense of movement rather than insisting on my own. The richness of this for me was that since it was unfamiliar, out of my own usual way of moving, it brought me to the moment, aware in this new way of only her needs and tempo. I began moving through each moment with a new lack of resistance to what was needed. As in the act of drawing, to walk with her, lift her, move alongside her, laugh with her, was just the next pen stroke, involving no hesitation. So often there were just a few words, mostly the pressure of my hands and arms responding to her movement.

I had the feeling that I could only observe O'Keeffe through surfaces, that I was acting as a membrane where things showed up, were recorded, while I remained unimportant as a personality. I was a function, a membrane tracing an existence but having no identity.

It would be to miss the point if one were to describe her as

Miss O'Keeffe

indomitable, as if she were constantly imposing her will on a situation, or as if her rational actions were ego-centered. I found in her a consistent willingness to change, with little moments of awe at an idea that seemed fresh and new.

People's inner processes fascinate me, and this affected my experience with Miss O'Keeffe. My questions were usually directed to her thoughts and ideas, not to her memories. I was less interested in stories of the past than in her observations of the moment, more interested in existing side by side, quietly in the present, than in turning the present into yet another memory by missing it entirely. There was more to be learned about her by listening to her ideas, for instance, or hearing her sigh or by watching her dim eyes look out beyond, this living being, determined in her resignation and alive in the moment, more interesting than a memory.

What was working in this relationship with O'Keeffe was in my giving up of my self, as a mother forgets her identity in the care of a child, foregoing her own inclinations in order to accommodate the other's. The instantaneous putting down the pen, if I were drawing, without thought, not insisting on finishing what one was doing before being of help. This release from self-absorption was the simplicity, resulting soon in an understanding of O'Keeffe's needs. There was no longer confusion as to what she required in order to live in comfort that particular moment.

Miss O'Keeffe

A fullness came in the giving up and thus, ironically, receiving. A friend noted the timing of this experience in my life, commenting on how fortuitous it was that I chose to care for an old dying woman, and this particular woman. By keeping in step with O'Keeffe, somewhere during that process I glimpsed a purity, like the sweetness found, felt, when one acquiesces to inevitable physical pain. That establishes an understanding of other purities. By moving within her movement, her own dying, with clarity of heart, I learned more, I saw how to live unseparated from those glimpses of purity.

Five

O'Keeffe was bathed at night, at least once each weekend. The water would be in the tub before Christine helped O'Keeffe in, of course, and there were safety mechanisms: a hand rail on the side, and a pad at the bottom. O'Keeffe loved to lie down the length of the tub with her knees bent and her feet up against an inverted rubber pan to shorten the length of the tub. She would lap water over herself and over her face and shoulders, moving her hands like wings. "Oh, how I love the feel of this warm water!" she'd say.

Nights in Abiquiu were long and cold. The fireplaces in both the studio and in O'Keeffe's room would hoard their warmth well after the last embers had turned to ash. Christine would put O'Keeffe to bed, loosening the blanket and sheets at the foot of the bed, making as much of a tent as possible for her feet. O'Keeffe slept with down slippers on. She loved them, once remark-

ing to Christine, "Don't you think these are the best slippers in the world?" They were of a light quilted parka material, flat when folded. Of course, by the time she woke up in the morning, they would have slipped off her feet.

Christine had been surprised at first to find that O'Keeffe slept in ruffled nightdresses. After O'Keeffe was in bed, Christine would sometimes light a candle next to her bed. The light comforted her. Then, in a little while, Christine would go in, find her asleep and blow the candle out. The image of that candle glowing in the little room, and of O'Keeffe's figure as she lay in bed, would become an intimate memory.

Before falling asleep, O'Keeffe would be likely to wish for a peaceful night. She'd say, "I hope I don't have bad dreams tonight." She was always most concerned that Christine would have a good night too, but it seldom turned out that way. O'Keeffe was a light sleeper who woke up during the night with various needs. Christine got to be able to tell the difference between the times she was merely restless, and those when she stirred and was ready to blow her whistle. In the middle of the night she was sometimes confused, and rude. She'd call Christine by different names. There had been another woman who had worked nights whose name

had been Cathy, but whom O'Keeffe had always called Cathay. She often called Christine by that name, or by any name beginning with the letters K or C. Only after a couple of months did she consistently use the name Christine. Some of the names she used (and which resurfaced when she was tired) were Catalina, Catherine, Chatterley. Once she called her Cherryblossom.

If someone wasn't right there when she needed help, she would blow her incredibly loud whistle. Sometimes nurses had been hard to summon in the night, so O'Keeffe wasn't shy about blowing a few hard blasts on her whistle.

At first Christine had tried to sleep also, but eventually, hounded by the shrill whistle, she realized that it was better to stay up and work on her drawings than struggle against the inevitable. She asked if it was all right to bring supplies so she could draw at the big table in the studio. O'Keeffe thought the idea was great. "Imagine that! Someone drawing in the room. Imagine that! Why, that is a very good idea."

She asked to see the drawings Christine began, but her vision wasn't clear at all; she could see major movements but she couldn't make out the details. Christine had started a series involving simple curving lines that became planes turning upon a single stillpoint. To one

with poor eyesight, this flow would appear as an overall curve. Nonetheless, O'Keeffe commented on the graceful curves. With more involved drawings, she would get confused and couldn't make out the total design.

Christine's paper sculptures were more accessible to O'Keeffe. She loved them because she could touch them, run her fingers along the folds of the paper. The shadows revealed their form to her.

And so Christine would draw and perhaps doze off for a couple of hours toward morning. O'Keeffe tended to sleep more soundly in the early morning hours, between two and four. After four, she'd start stirring, thinking it was already six and that she could get up.

It was futile to try to sleep at other times if, in fact, she was going to answer O'Keeffe's needs and respond to those whistle blasts. It was easier not to sleep than to be awakened each time just as she was dozing off.

There was enough quiet time during the day when they'd just sit together by the fire and calmly do nothing that Christine somehow got the rest she needed during her weekends in Abiquiu. Besides, Christine was used to odd hours. For many years, involved with raising her sons and running a business, she'd get up in the middle of the night and draw; it was the only time she had to do it.

Miss O'Keeffe

When O'Keeffe would go to bed now, she'd ask Christine if she was going to draw, or she'd tell her to go and draw but to be sure and get enough sleep. She wasn't aware how disruptive her whistle could be. And while Christine didn't mind getting up, or staying up and answering her calls, she did mind the whistle. She tried to get O'Keeffe simply to call her, and there were times when she did just that, but O'Keeffe had grown used to her beloved gadget. Christine had to place it by her bed because it made O'Keeffe feel secure.

If Christine was drawing when O'Keeffe blew the whistle, Christine would cross the big room and the small bathroom and be in the bedroom in no time. But by then O'Keeffe might be struggling to get out of bed, or she'd be sitting up. If Christine had actually been asleep and had taken a little longer getting up to answer the call she would see O'Keeffe's small figure in the glow from the bathroom light, a dark silhouette starting to move toward the door if she had made it out of bed. O'Keeffe might be all the way into the bathroom if Christine had to get out of bed, put her robe on and cross two rooms.

They had many chats about the beauty of early morning, the tranquillity of those hours when Christine found it easiest to work. They shared a love of dawn.

Miss O'Keeffe

Christine would wake O'Keeffe up at six o'clock if she wasn't yet awake. She'd be very excited that it was time to get up. Christine would build a little fire in the bedroom and go make their breakfast.

At first, she thought that O'Keeffe was happy to be up, to have it be morning, because she spent such restless nights and could now get back to some sort of activity that made sense to her, away from the possibility of dreams; but, finally, she had to conclude that O'Keeffe was just delighted to be alive in the early morning. She said to Christine once, "Can you imagine sleeping late?" She couldn't understand how anyone could sleep after six o'clock. "I like to get up early. I think one misses a great deal if one doesn't get up early in the morning."

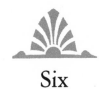

Six

I had always touched her face, because I would put cream on it every night.

From the very beginning the nature of our relationship was such that there was physical contact; I was taking her clothes off, I was lifting her up into the bathtub, caring for her every need, walking her to the bathroom, helping her wash her hands. Before touching her with my cold hands, I'd wash them in warm water, which is what she had once suggested.

She'd ask me to please get my hair out of her face when I moved her. I had rather long, curly hair, so I started to wear the right side of my hair back because that was always the side from which I'd help her in the bathtub. I remember her saying, "That hair!" when it would brush against her face.

At first she was Georgia O'Keeffe, the artist, but soon, the name went away and there was just a relationship of two human beings. She appreciated the smallest thing; if I handed her a piece of soap she might remark, "Oh, wasn't that nice

of you!" She was conscious of everything that was done. Much of our conversation was purely human, concerned with detail: "Would you like to move over to this chair?" "Oh yes, that's such a comfortable chair. Do you like rocking chairs?"

She responded to even the simplest gesture, saying perhaps, "Thank you! Thank you! This is the finest." One afternoon after a nap when I gave her a towel with a hot, wet corner to wipe her eyes, she said, "Aren't I lucky to have you help me!" She would laugh when I'd help lift her legs into bed: "Well, isn't that a help! Are you still painting, drawing? I just needed some help with this business. Good for you. Go draw!"

There was an easing; I wasn't this younger woman and she wasn't this older woman. I was a person standing next to another person handing her soap, making life easier. There were no categories.

The first day, when Pita showed me the place, she had shown me Claudia's room—so-called because a sister of O'Keeffe's named Claudia would sometimes come visiting and stay in that room. This room had a bathroom and Pita had told me that I could feel free to take a bath there on the weekends. The first night that I was there Miss O'Keeffe told me to take baths in her own bathtub and she said to be sure to enjoy myself because it was a very good bathtub.

Her manners were so elegant and her concern for others so consistent that they could not have been faked at this point

in her life. They would have had to be there all along, such awareness acute during her lifetime in order to end up with that kind of grace.

She would sometimes show concern or start a conversation by reaching over and putting a hand on my arm or on my hand. It was a way of punctuating what she was going to say, or a preface to speaking. And often she would put her hand in my lap, looking for my hand to hold.

This mellowing of her previously described abrasive manner is more than it seems. I think it was a further manifestation of her relentless insistence on simplicity. She seemed more interested in a simple gesture such as a touch of the hand or brushing a stray hair from her face with the back of her long hand, than in discussing the fifty-thousand people who trekked through the exhibit of her work in Madison, Wisconsin. "Yes, my paintings have been much liked," she said, then she was back to the issue at hand, fingering her handkerchief, asking about the lace on it. She relentlessly returned her attention to the present.

In some old people one can observe a stubborn resistance to change, an unwillingness to accept it. Georgia welcomed whatever length of walk she was able to take that particular day, not lamenting failing powers, but acknowledging the pleasure of what she could do.

I got to the studio one evening at five o'clock. She was sit-

ting up on the studio table with her legs crossed like a sexy secretary. Pita and Hamilton were in the room and she was just sitting there as if she were twenty-five years old. I have no idea how she got up there; Hamilton must have lifted her. They were bantering when I arrived. Pita and I helped her down, all of us laughing.

Only a few times did I hear her complain. One time, getting up, she remarked, "I don't know how I can get through another day! I don't know why I have to." Several times, at dinner, "Oh, what I'd give for some salt!" She'd laugh at herself. I never heard her complain that the food lacked flavor even though it was obvious some tastes didn't come across.

She once told me the only regret she had was that she hadn't kept a diary. She said, "I think I know now that my life is never going to look right."

I had the sense that her identity and presence were unaffected by her surroundings, except to the extent that she allowed herself to be part of it. Her strength came from within, a depth of character which was centered and inviolate. I saw in her behavior at the time a lack of ego, and was unprepared for the glimpses of humility that appeared with regularity. For instance, when I asked her to sign my copy of her book, she seemed very surprised and said, "Well, of course. But it's not going to look very good, you know. I can't write very well anymore because I can't see well enough."

Miss O'Keeffe

I assured her it would be all right and she asked me how to spell my name exactly and what date it was. She wrote, "For Christine" and the date and handed the book back to me. I looked at it and said, "Well, Miss O'Keeffe, I was hoping you would sign your name too." And she said, "Oh, you want my name. Well, of course, here, give it back to me." And she wrote her name.

Seven

Turning up the hill in Abiquiu to the house, Christine would sense a feeling of peace come over her. She would bring with her the power of the land she had just driven through. It would be nearing five o'clock Friday afternoon and either Pita or one of her brothers—the Lopez "boys," as everyone called them—would be there waiting for her in the studio. That is because there was no nurse during the week in the daytime. Pita took care of whatever was needed in addition to doing the office work, and her mother, Candelaria, would cook the meals. If it was Pita there to greet her, her car would be in the driveway and she and O'Keeffe would be waiting inside the studio. Christine would close the inner gate, sometimes juggling the container of soup she liked to bring O'Keeffe, some drawing paper and her overnight bag. The two O'Keeffe chow dogs, Inca and Chia, would run up to her, barking. Chia, the younger,

would be moving, jumping, barking, playing the sentinel, while Inca would head back in boredom toward the studio; he would see his mistress through the glass door, and Christine would follow him, forcing open the sliding door, which was hard to manage.

One afternoon she arrived and was greeted with, "Well, hello. Are you going to cook dinner now?" She and Pita laughed. "In just a minute, Miss O'Keeffe," Christine replied. "I'm going to put my bag down and say hello to Pita, then I'll go over and heat up this mushroom soup I made for you. How does that sound?"

"Well, that sounds just fine," O'Keeffe said unconvincingly. When O'Keeffe tasted the soup she exclaimed, "My, this is fine soup!" Christine's mushroom soup had a flavor she could detect distinctly.

Meantime, Christine had spotted stale bread in the fridge; she decided she would have O'Keeffe help her make some the next day.

The Lopez brothers, Mino and Maggie—and another brother who wasn't around much—did whatever work was necessary. For example, one snowy Monday morning Christine went out and opened the gate to let them in. This gate, which led into the compound, was always locked. It is the one Pita opened to let Christine in the first time she was there. On Fridays they would leave

this gate unlocked, knowing that Christine would be coming. People didn't seem to have keys, so on Monday mornings Christine would have to go out and unlock the gate for Candelaria and the others.

On this particular snowy morning, the Lopez brothers came and got to work immediately clearing the patio area and the driveway. They made the passage easier to negotiate.

They were the ones who brought wood from the nearby hills and made sure there was a large firewood pile at all times. The fires in the fireplaces would always start right away because they provided starter wood, kindling called *ocote* which ignites as soon as you touch a match to it. The firewood would be set up in the fireplace in the New Mexico style, leaning up against the back of the fireplace. With that and a bit of newspaper Christine would have a fire going in no time. So there were always those wonderful fires around the place.

Once or twice she had trouble with the small fireplace in the bedroom and then she'd have to serve O'Keeffe her breakfast in the studio. This happened when it was particularly cold and windy and she had forgotten that on days like that she had to heat up the chimney a bit with a lighted newspaper before starting a fire. O'Keeffe would laugh and say, "Well, that's life, isn't it?"

Miss O'Keeffe

The weather in Abiquiu that fall was blustery and winter-like. With the fires going, things were intimate and not to be forgotten. Christine's favorite feelings were connected with the studio when she was alone with O'Keeffe. Though the studio was a large room, the feeling was one of intimacy and well-being, of protection from the elements outside.

O'Keeffe loved having fires in the rooms. She would get cold easily and so she'd sit on the side of the table near the fire. In her room in the mornings she'd sit near the fire there.

To keep the fires going, Christine would go to a little room off the studio. There was a stack of wood in that room and a pile of newspapers plus a bucket for the ashes when it was time to clean the fireplaces. The room was redolent with the smell of wood. It led out to a passage around the house toward the patio on the north side where more wood was to be found. Just going out to that woodpile was exhilarating. There was a clothes-line out there where once in a while Christine would hang clothes if the dryer wasn't working. She liked to hang and air the bedding she washed each week; as for clothes, she found that O'Keeffe had so many it wasn't necessary to wash on the weekends.

She changed the sheets from her bed and from

Miss O'Keeffe

O'Keeffe's bed on Sunday afternoons or Monday mornings before she left. She did vacuuming on Sunday afternoons. It was always a bit of a problem because O'Keeffe hated the sound of the vacuum cleaner. Christine would do a bit at a time and have her as far away from the activity as possible, sitting by the door looking out or by the fireplace while she did the bedroom behind closed doors. When O'Keeffe was back in the bedroom for a nap, Christine would do the studio.

On one particularly beautiful Sunday afternoon, Christine baked bread. They sat for a long time in front of the fire in the studio with their feet up. O'Keeffe had been asking Christine questions about her children and as the afternoon lengthened, snow was silently accumulating outside. It kept coming down with the intensity of silent things. Christine was to leave since another nurse was coming to spend the night; but when the nurse arrived around five o'clock, and Christine made ready to go, O'Keeffe became very concerned about the snow. It had been snowing all weekend and the roads were treacherous. She asked Christine to stay in Claudia's room until the snow was all gone. She looked thoughtfully off at the distance past the window and said, "But I suppose the snow will stay for a long time on those roads . . ."

Miss O'Keeffe

She reached over and took Christine's arm, asking her to drive very carefully. "Now, Christine, would you promise to call me the minute you get home and let me know you are all right?" she asked.

Christine called her when she got home. The trip had taken her a long time because the roads were indeed bad, particularly between Abiquiu and Española. It hadn't been a very pleasant drive home. O'Keeffe asked, "Is it warm there?"

Christine felt strongly about the Abiquiu house and those Abiquiu days. She appreciated each room, almost as if each had a personality of its own and something to give the person entering it. The pantry was one of her favorite spots. She felt that it would have been a wonderful place for a family to grow up with, that it would have given them a sense of true security and warmth. One could imagine gatherings, parties and feasts, music and talk; perhaps, at other times, just a woman working silently, and lovingly caring for it. It was the heart of the home. O'Keeffe's surroundings have often been described as austere, but Christine found that not to be true. There were clean lines and a meticulous sensibility. Things were neatly placed and designed, but in no way was any room cold or stark.

Miss O'Keeffe

The pantry was lined with shelves full of neatly orga-
nized old pots and pans, bowls and trays, and cast
iron skillets that were very old but still in use. Narrow
shelves contained jars of flours and grains: rice, millet,
barley; there were herbs and teas, camomile, dried
lovage and parsley that Christine assumed to be out of
the garden. The jars were dated, 1983, 1982, so one
could see that Candelaria was carefully storing part of
the harvest from the very large garden.

But nothing was simply jammed in; things were care-
fully organized. It was clear that the pots had been
washed and scrubbed and polished over and over. An
electric mixer looked old enough to date back to the for-
ties or fifties. All the traces of humanity in that pantry
revealed a continuity central to that house.

The kitchen was simple; it had not been renovated
for a long time, perhaps never. It had an old sink, and
the oven was not particularly reliable. The heat would
vary, so things took some watching. Christine had to
use her judgment especially when baking bread.

The dishwasher didn't work. The floor was linoleum.
The furniture was simple; ladderback chairs were pulled
up to the plank table.

The entry to the pantry was a service porch; the dog

food was stored in a corner and the washer and dryer were there. On the opposite wall, there were large freezers for steaks, meats, and vegetables. Christine recalls that at Thanksgiving time she made a ring of bread and put it in one of the freezers for O'Keeffe to have for dinner, since she was not going to be there for the festivities. It was not eaten so she and O'Keeffe finished it off the following weekend.

Except for the lunches O'Keeffe ate by herself there, the dining room was only used when company came or during special occasions and holidays. It had a dirt floor hardened with animal blood. It was almost as hard as concrete, but looked as if it were made of some soft material, like suede. It added to continuity in that house, the sense of old adobe found also in the living room where the floor was that same mixture of mud and blood, giving it a lovely, New Mexican color.

The so-called Indian room, off the kitchen, did have an austere quality to it. O'Keeffe had told Christine how in the old days Indians would come through and how when they needed a place to stay she would let them sleep there overnight. At present, it was another storage area. Because the room was cold, they kept food there, cases of wine and boxes of apples and other fruit.

Miss O'Keeffe

There was a sign over the apples saying to wash them because they had been sprayed.

The studio was a long room which had been carpeted in recent years, probably to facilitate O'Keeffe's walking as well as to make it warmer. Beneath the carpet was a dirt floor. The north side of the room had been turned into an office; there were shelves, files, a typewriter, a Xerox machine, sawhorses supporting a plank desk on which were a Rolodex and a three-foot-tall sculpture of O'Keeffe's.

The plank was plywood; it had probably been rubbed long before with white paint and maybe a bit of varnish, or perhaps it had been waxed a lot. There was no roughness to it at all; it was smooth but not a highly polished piece of furniture. Like everything else, it was simple and matter-of-fact.

There were a couple of chairs around the desk. The fireplace was at that end of the room; the other side was a sliding glass door opening to the courtyard. Along that same wall were a shelf and a counter where O'Keeffe's gloves and some keys were neatly placed. Whenever she got up from her white chair to go to the other end of the studio or to go outside, she would be leaning on her cane with her right hand, but she would invariably pass

her other hand over a stone she had on that shelf. This stone, about the size of a large potato, was extremely smooth, with beautiful markings.

Beside the counter was a sink compartment that no longer functioned as a sink. They kept pills there; underneath was a cabinet where O'Keeffe kept some of her very carefully wrapped treasures in boxes. To the left of the bathroom door was a small table with a telephone and some books and magazines. Then came her armless chair covered with a white muslin slip cover. The day bed was beneath a large window on whose ledge O'Keeffe kept stones and fossils she had picked up here and there. She would nap on that bed during the day, and Christine slept part of the night on it. The bedspread was a white muslin sheet.

At the foot of the bed was a modern black leather chair. It was later replaced with a very comfortable tubular chair arrangement that could lean back, something advertised in the *New Yorker*. There was a black canvas butterfly chair and a white molded plastic chair, which were moved around the room as they were needed. The north wall behind the long table held a counter with a typewriter where Pita did a lot of her work during the week. She had a small desk. Near the copying machine was the door leading to the wood room. On the oppo-

site wall, underneath the long counter, was the storage area for office supplies, open shelves covered with plain muslin curtains.

O'Keeffe liked to sit in the white slip-covered chair at the end of the room. Her telephone list consisted of cards on which the telephone numbers of people she liked to call were written, large and obvious, with a black felt-tip pen. When Christine was there O'Keeffe no longer used them herself, they were something she had used before; she had Christine dial from those cards. At supper time, Christine would take the phone off the little table and serve the meal there on a tray.

There were fluorescent lights in the room, perhaps a lamp over by the desk, a lamp by the end of the day-bed. The *vigas* or wood beams in the ceiling had been rubbed with white, softening the feeling of the wood.

On the same wall as the window was the good New Mexican fireplace often used all day long on fall and winter weekends. Christine and O'Keeffe had many wonderful afternoons in front of that fire, talking. They would reminisce about their lives, sometimes laughing over nothing. It was a quiet world, muffled and away from the busyness of life in the big cities. In that ambience, the least thing acquired an importance all its own, a significance it might not have had if there had

been other things for Christine to think about. Time was their distinguished visitor, and the silence of the land beyond the few noises of the small village and the barking of dogs was all they had to listen to besides memory.

O'Keeffe's bedroom had a sense of accumulated silence accentuated by the curtains, opened during the daylight hours. The first time Christine was there, it brought to her mind a childhood memory of the catacombs in Italy where the stillness was overpowering but not oppressive or depressing. What she sensed in that bedroom was a timeless, mysterious sense of human power confined by the walls. No other room in the Abiquiu house gave her that powerful, cool, enduring sense of resonance curtailed by the absence of sound. There seemed to be a silent, dull and distant ringing emanating from the walls and floor. It was always cool in spite of the *kiva* fireplace with its embers glowing in the corner.

The bed was a double hospital bed up against the wall beneath a ledge containing a good number of stones very simply placed. There were no paintings in the room; it was spare and rather monastic. Two large windows overlooked the road below. If one were driv-

ing from Santa Fe and looked up, those two bedroom windows at the corner of the house were the very first thing one would see.

The room was too small for an armoire. All of O'Keeffe's clothes were kept in the bathroom, in closets and drawers built for that purpose. The bed was covered with a piece of muslin that looked like an old sheet, torn at the edges and without a hem. A corrugated foam pad was used under the sheets. O'Keeffe had two silk comforters. One was black and the other had orange and green stripes. Both had their stuffing showing through. This bothered Christine and she started repairing the black one. She purchased new silk to cover it with, but the job proved immense. She was sewing it by hand, and it was still unfinished when Christine left.

It was as if O'Keeffe had never realized that she was wealthy. Linen items had not been replaced just because they showed wear. There was an assumption pervading her existence that real elegance is found in continuing to use material goods as they aged. It was a kind of humility. There was a sense that decay had to be accepted as one of the conditions of life.

There was much in Abiquiu like that. The muslin curtains in the studio cupboards were not new; they

were frayed at the edges but were very neatly ironed by Candelaria in the kitchen mangle. Here again one found the opposite of arrogance; an understanding of the simplicities of life that had nothing to do with being pretentious.

Eight

I'd get her up in the morning, exactly at six o'clock, as she requested, every single morning. She had a keen sense of the hour: at two minutes to six she would call, "Christine?" or "Cathay, is it six o'clock?" although occasionally, she'd start doing that as early as two o'clock in the morning. Sometimes, after a long night of bathroom calls, bad dreams and questions about the time, I hoped Miss O'Keeffe would sleep late. That seldom happened.

I would put her legs up and start the fire in her bedroom. I started a fire in the studio as well before she woke up, so that things would be a little warm for her. The elevating of the legs was something we had to do for twenty minutes every few hours since her legs tended to swell. During the day she would lie down on the daybed in the studio for this but on first arising I would prop her legs up in bed with two or three pillows under them.

Then I would go out to the kitchen and begin breakfast. I

was always nervous leaving her alone so I didn't like to take long making breakfast. Still, I had about half an hour, since she had to have her legs up.

"Is the door closed, Christine?" she would ask, wanting her privacy in this familiar setting, privacy from some imagined visitor in the long, adjacent studio.

"Oh yes, Miss O'Keeffe, it's closed," I'd say, having closed it earlier to keep the warmth of the fireplace in.

She would eat around six-thirty in the morning. It was almost a ritual, for it would always follow the same sequence and there was a sense of honoring one more day. She would have breakfast in her robe, a garment she called her wrapper. I'd set her breakfast on a folding table and sit beside her, helping her to eat. The curtains would usually still be closed because of the cold at that time of the year. When it wasn't so cold I'd open the curtains and we'd have more light in the room. Otherwise it would be dark and intimate with a low, incandescent light.

If she wanted to eat a piece of fruit I'd cut it up and then she would eat it with a fork. I always prepared the food so that it was easy for her to eat. She was very much the lady; she had impeccable manners. There was a certain way she folded her napkin; she was quite careful with it. In general, she was very deliberate and very slow; she took her time with things.

After breakfast I would help her up and take her to the

bathroom where she would sit on a chair while I bathed her
with a washcloth. She usually took a full bath the night be-
fore. She would always ask that I be careful of the small skin
cancer spots on her face, which I afterwards treated with spe-
cial cream. "You're not touching the spots, are you?" she asked
while I washed her face. She was always very careful not to
touch them herself. Putting medicine on them was referred to
as 'spotting.'

After washing her came dressing. Everything was very well
kept. Candelaria was very good about keeping O'Keeffe's clothes
beautifully ironed and neatly sorted in the closet. O'Keeffe had
linen handkerchiefs, some plain, some with lace. I often gave
her one to have in her pocket, and she would keep it very neat,
always folding it perfectly after using it. She often held a tis-
sue in her hand and would daub at the corners of her eyes, for
they had a tendency to tear.

Her dresses and suits hung in meticulous order in the closet,
black kimono-style dresses, with an occasional pink, grey or
light blue, dresses obviously meant for the springtime. They
were worn with a similar, but lighter, white underdress. The
act of dressing her was a stationary dance; her movements were
so well chosen that there was no wasted motion. She had a
sense, a memory of how to dress that she repeated over and
over. She wore nylon stockings and a garter belt and a full
silk or nylon slip beneath her dresses. Sometimes she would

wear black pantsuits. On very cold days she wore silk knit underwear, neat stuff that kept her warm. When I dressed her in the morning, she was susceptible to the cold, so it was important to dress her quickly. On cold mornings I would take her underwear and put it in the dryer or on the hot radiator right before I put it on her. She loved that. On cold evenings I would warm her nightgown before she put it on.

"Aren't these fine shoes?" she said once as I finished dressing her, referring to the dark suede driving shoes she wore, shoes with crepe soles curving up the back of the heel slightly. "Why, I can walk all day long in a shoe as fine as this."

I was reminded that someone had told me once that getting old felt like having pebbles in one's shoes. "It's good to see you take such pleasure in a shoe, Miss O'Keeffe," I replied.

"Well, we wouldn't want to have a shoe that hurt us, now would we?" O'Keeffe said laughing.

The fact that she wore driving shoes made me ask how long it had been since she had driven a car, remembering her old Ford and how she had taken it everywhere to paint the landscape.

"Oh my goodness," she laughed. "I'd be a terror on the roads now, wouldn't I?"

By now I had her sitting in a small white chair in the studio by the warmth of the piñon fire. Her feet were up on a wooden stool.

Miss O'Keeffe

"My, isn't this fine?" O'Keeffe commented, only to continue the conversation a minute later. "There are times when I go in a car now, but I don't drive. Someone else must drive because, you know, I don't see as well as I used to. I don't think it would be much of a good idea for me to do that anymore, do you?" She laughed, "I used to get in that car and go and go all over the place. And now I can't do that anymore. That's a different way to live when you have to depend on others to take you driving."

She'd get irritated if I left the closet door open so, when dressing her, I'd be opening and closing that door a number of times. Such things bothered her; everything had to be in its place. I saw a relationship between this exactness and the precision of her thought and art.

After dressing she was ready for the studio. By the time I had dressed her the fire in the studio would be roaring and she could sit in front of it. That was about seven-thirty in the morning. It was still early morning and we'd have artificial lights. Soon after that I'd open the curtains and we wouldn't need the lights.

At lunch time I would go to the kitchen and fix the noon meal. There was a little fireplace in the dining room and when I went over to the kitchen the first thing I did was to start the fire. In the morning I would have taken some meat out of the freezer for the noon meal. That was the main meal, the one

eaten with ceremony. It was served in the dining room where the table was set formally with silver and a cloth napkin.

One of the Lopez brothers, usually Maggie, would have spent the night at the other end of the compound, coming by around ten o'clock at night to check on things. He would sleep in the north bedroom, a room with an easel in it. I recall that he would check in with me sometimes but we were usually closed in for the night since I would put Georgia to bed around seven. Every now and then, I would see him in the mornings.

Hamilton would come only occasionally and stay for a few minutes. So, usually, Saturdays were delicious because it would be just Georgia and me and there were no interruptions at all. We got into a rhythm. It wasn't always the same, but there were repeated motions, like the moving over to the chair in front of the fireplace. After about an hour she would want to lie down on the daybed underneath the long window. I'd see her lying there and see the meadows across the road, and things seemed very good to me then. She took naps there with all her beloved rocks and bones on the window ledge above her. It made a lovely setting. Calvin Klein lay on that bed in the summer of 1984; Hamilton talked for days about Klein coming to photograph out in Abiquiu for a series of ads. We were in Santa Fe by then, and when he brought Klein in to greet O'Keeffe, she sat up very straight and looked around the room

trying to tell the difference between them, getting them mixed up. She would stare at one when the other was speaking.

On a sunny day in Abiquiu she would sit by the sliding glass door and I would be running about my business, going to the kitchen to cook or clean up, or I'd pull up a chair and join her. I never sat in her white chair near the door leading to the bathroom. That was her chair. You could see that its slipcover had been washed quite a number of times, it was clean but no longer bright. She ate her evening meal there around five o'clock in the evening—not later than five-thirty. She used to say that she couldn't imagine why people would want to eat later than that because it would be disturbing to their sleep.

She could sense what time it was, sense it was time for me to go and work in the kitchen, and that's what she called it, "your work in the kitchen." Sometimes she would go over there with me and just sit on a chair while I worked, wanting to be in on the day.

I was told in the beginning that on the weekends there would be a lot of leftovers that O'Keeffe was to be served and there were other things in the freezer, steaks and chops and things like that. At first that is what I served her but after a while I didn't like the leftover idea so I started bringing homemade soups and things, livening up the menu.

I looked forward to those times in the kitchen when we baked

bread. O'Keeffe had had the habit, earlier in life, of baking bread regularly. I loved to bake bread, so I told her it would be fun to do it with her.

Georgia and I wore white aprons which Candelaria had ironed. She sat on a chair at the kitchen table. When I was mixing the dough, she spoke about the yeast. "It's the most important part of the bread, you know. If you don't treat the yeast right, your bread won't be any good." An experienced breadmaker, I had my own memories of bread dough not rising properly, and I took care to treat it with respect.

"Is it time for me to knead yet, Christine?" she asked, re-treating into silence when I told her it would be a little longer. A few minutes later she started to speak, then seemed to think better of it. "I suppose you'll just bring it to me, won't you, and I don't need to worry about it. It's a pleasure to be thinking about kneading bread again."

I handed her a very small piece of the dough—enough to make a large dinner roll. She used her hands in a very delib-erate way, not able to get much pressure with them because she was sitting down. I worked at the end of the table, facing her. She pushed the dough very slowly and firmly with her open hands, then carefully folded the flattened mass, turning it slightly to one side as she did, the memory of past ritual firmly ingrained. Her face softened, color came to her cheeks.

"It is warm, you know," she said. I replied that bread

Miss O'Keeffe

dough had always reminded me of a warm baby, and if we rest a quiet hand on the dough we can feel the life of the yeast. A minute after she began kneading, she asked if it was enough and was glad that it was not. She sat with her feet flat on the floor as was her habit, leaning slightly toward the table, which was a little too high to knead comfortably. She seemed to be meditating, receiving something significant from that bread.

When it was time to put the dough back in the bowls for the first rising, she said this had been a fine way to spend a windy morning. "I suppose we'll eat the bread for dinner now, won't we? I think it takes longer to bake than the Irish soda bread, but I suppose we'll have it for dinner."

She lamented the loss of her former ability to go through the whole job of making bread. She said it had been very satisfying to her and she was very happy that we were actually doing that.

She told me once to "Go get Mary's book." Mary had been one of her employees a long time back who had left a book with recipes in it, a lot of the things she liked. One of them was Irish soda bread. She said, "You know I'm Irish. Go to the kitchen; there is a book there and that's Mary's book and in the book you'll find a recipe for Irish soda bread. Now, you can make that bread, and it doesn't take very long. And it's the best bread in the world because it's Irish bread!"

When I would tell her I was going to serve bread for din-

ner she'd brighten up and say, "Oh, that's very good news."
Whenever she was particularly alert at dinnertime or when I
went over to make our dinner, she would often ask, "Isn't there
any bread? Would you like to make some Irish soda bread? It
doesn't take very long to make, you know. You just take the
recipe out of the recipe book. It's very quick."

Being Irish meant a lot to O'Keeffe. Once I heard her on the
phone talking to a friend and saying, "You know I'm Irish
and that helps a lot. I don't know what people do if they
don't have a little Irish. Are you Irish, Mike? No? Well, for
heaven's sake, go out and get some right away!"

At least once a day in good weather we would take a walk
around her driveway, often twice. This was a fair distance to
go. We would walk around four to seven times, placing stones
in a particular place to mark the times around. She insisted
upon this longstanding ritual of stone placing.

On chilly days she would wear a coat and gloves to go out-
side. She would insist that I put on one of her coats and gloves
as well. It made her very happy when I dressed as warmly
as she did. We would go to the gate, where she would have
to wait while I opened it. The gate was kept locked and it
was somewhat of an ordeal to get through it. The driveway
and parking area were very wide. There was a place outside
Claudia's room where we would accumulate the rocks we used
to mark our trips around the area. We'd leave them in a row.

Miss O'Keeffe

She would ask me to count the rocks even when I could remember the number of times we had walked around. She was very insistent that we get the facts right; it was a habit that provided continuity.

As we walked around the driveway I would describe to her the different colors of the trees or the quality of the light coming through the branches or any kind of change in the yard that could be noticed. She often worried about the large gate by the road and would stand by a tree, an arm around its trunk, while I went to close it so no intruders could come in while we were there. It was a different gate from the one which led to the courtyard outside the studio.

She seemed, when we were walking, very oriental, rather like a Ming sage or statue. She seemed very frail. I am a short woman but I felt quite tall walking beside her.

By early spring 1984 a two-hundred-foot walk was maximum for her, and by summer, half that seemed to be her tolerance. How different from the old days at Ghost Ranch, where she roamed the countryside. She said, "I walked around through the hills and there were paths made from one thing and another so I'd follow the path and the path would lead to a waterway where the water ran and made a path. I used to walk over hills that were very steep. The way I'd know where to go was a dead tree over there and I'd walk toward the dead tree and the only thing left was a rock like a chair; it

was a stone chair and it sat there by itself. I'd always sit on it because I'd be very tired when I had walked across. I had walked that path the horse had made when it was not used to being ridden anymore.

"In the early days when the house was first built, a man at Ghost Ranch would ride across to the house and I would ride to a dead tree over there and I stayed out in the engine house.

"I would walk down an arroyo *and follow that until I got to the end of it. And before people lived in that place I never saw anybody's tracks but my own. It was much nicer before."*

In the fall of 1983 and winter of 1984 she was still feeding herself. I would bring her breakfast and her supper into the studio or she'd eat on a little table in her bedroom, in a corner beneath a window where she would be warm if there were sunshine.

She would sit quite erect and focus down on the tray. She could see the bowl or the plate; she couldn't necessarily see where the food was all the time because she would often bring her fork up as if it had food and bring it to her mouth when there'd be nothing on it. And she would try again without any sense of frustration or any reaction whatsoever. It was just part of the process. Sometimes there would be food on it and sometimes there would not be food on it.

By the time Hamilton moved her to Santa Fe in the spring of 1984 she was no longer able to feed herself as well and

Miss O'Keeffe

I would not only prepare the food but also spoon it into her mouth. At dinnertime I'd encourage her to eat by herself. It would take a long time, an hour for her to eat her dinner, and even then she might not finish it. She would ask to please be fed the other meals because she had so much trouble; it was exhausting to her and she was beginning to get very disheartened by the whole process.

Because it took her so long to eat I would heat the plates so the food would stay warm longer. The dishes used in Abiquiu were very plain white china with simple lines. When she had tea she liked to have it in a real teacup, with a saucer and silver cutlery, and I would put a placemat on her tray.

I always decided what I would fix based mainly on what was available in the kitchen. I would ask what she wanted but she never seemed to have a clear idea; she'd just say, "Go fix whatever you want, that's your job." She often liked to have pancakes, yet she didn't like me gone long enough to fix them. I experienced a sense of frustration not only in Abiquiu but in Santa Fe because the cooking area was always a considerable distance from where she would be and so, in order to monitor her and do the cooking, there was a lot of running back and forth.

She didn't have much of a sweet tooth, though she went for chile jelly. She liked fresh foods and had a big garden in Abiquiu, so she was used to fresh vegetables cooked slightly. Since

Miss O'Keeffe

it was nearing winter, there were few vegetables in the garden anymore. I don't know what Candelaria cooked during the week; Hamilton would be eating there then, and Candelaria would cook for everyone.

She loved wheat toast at breakfast, especially with a little bit of honey on it. She liked to eat lamb and boiled onions. She used to say that one can never put too much garlic in anything. She liked to have popovers; she liked millet and eggs and omelets. Sometimes for breakfast I'd make her an omelet with sprouts and garlic and chopped-up vegetables on top. She favored lovage, a plant with a flavor between celery and cilantro. And she would ask for short-grained rice.

She liked to drink camomile tea before she went to bed at night. And a few times she told me that somewhere in the kitchen there should be an open bottle of wine and that it probably wouldn't hurt to have just half a glass before she went to sleep.

Nine

In the afternoon after O'Keeffe had taken her usual nap the two women would be sitting around. O'Keeffe would sometimes offer to talk about old times, or she would have Christine read to her. She liked articles from some magazines, so Christine would go through the tables of contents and then O'Keeffe would choose something. She was most likely to pick things that had to do with what already concerned her. She didn't care for articles of general interest. Articles on heart problems or toxemia were sure to interest her.

Christine recalls a number of times when O'Keeffe would interrupt and say, "Well, that's not particularly interesting, is it? Why don't we go do something else?" or, "Don't you have something better to read to me?"

One of the books she enjoyed was *The Book of Tea*. She loved for Christine to read from it. She would light up when she thought of that book. She wouldn't listen

to very much of it, just a few lines at a time, but she would think about them. It started one day when she asked Christine to go to the "book room" to look for the book. Christine had been working for O'Keeffe for more than a month and didn't even know such a thing as a book room existed. That a room with books would be called the book room was characteristic of O'Keeffe's way: she was very direct about everything.

When Christine expressed surprise about it, O'Keeffe said, "Don't you know where that is? Well, you just go around to the back. Go over there and pick up the key; the key will be there on that key chain by the door."

The room was reached by walking across the court-yard. It was beyond the garage and Claudia's room, and was quite musty inside. It didn't seem to be more than twelve to fifteen feet square and there were books all over the walls, a remarkable collection of biographies, art books, and other items. O'Keeffe said she had been collecting them for years and that some of them were Stieglitz's.

The books were not in any recognizable order, so when O'Keeffe sent Christine to look for this or that title, Christine had a hard time locating it. She found *The Book of Tea* the second time she was sent for it.

Miss O'Keeffe

O'Keeffe had wanted it urgently, and Christine had searched all over.

When they first started reading from *The Book of Tea*, O'Keeffe said, "Turn to the pages about flowers. He understands about flowers. You know, he says that a butterfly is a flower with wings. Don't you think that is a fine idea?" Christine told her she had always thought of the opening of flower petals as a beginning of flight, of the blossom getting ready to take off into the universe. "If we imagine things faster, they fly." O'Keeffe responded, "Oh yes, have you ever watched an iris open? I have very beautiful flowers and I've watched them open, and they will be here after I'm gone, I suppose."

They were reading a book by Calvin Tomkins, and it mentioned Marcel Duchamp. That prompted a whole story from O'Keeffe about the time she had gone to a dinner and Duchamp and others had been there.

"There was a party at his house [Calvin Tomkins'] and I walked into that house and on one end of the room there was a counter with food placed in a certain order on it. And behind there was a musical set-up . . . well, the things that John Cage used for his kind of music. But you couldn't see it all because it was be-

hind the counter. And at the other end of the room was a circle of flowers for Merce Cunningham's dance. You see, I didn't know he was a dancer; that's the first I ever saw of him.

"Duchamp was a good friend of mine. I knew him well for a long time in New York. He lived in New York, you see. Stieglitz photographed him; a very good photograph, actually.

"I was visiting a friend and I told her how I wanted to go to the Cunningham dance, but she didn't want to go and she didn't want me to go, but I went anyway just the same. And after the show I went back to talk to them [Cunningham and Cage] and asked them if they would like to come to lunch tomorrow. Well, they seemed pleased at the idea and said they would.

"Well, here was this woman, my friend, who didn't even want me to go see these people dance and she was very surprised that she was entertaining them for lunch. And it turned out that she liked them very much and told them that she had a room that she kept for artists, and sometimes it was full and sometimes it was empty, and the next time they came to New York they should call her up and if it was empty they should stay with her. And she didn't even want to go to the dance and she

didn't want me to go. I thought that was pretty funny.

"I had a friend, a woman who was a painter, and she would work on a painting for a long time and when it was finished she would tell us—it was a certain group of people—that we could go and see her painting. So I went to see her painting and I was seated at a table very near the painting drinking something or other out of a glass and I finished it and put the glass in front of me. Duchamp walked over to me and very slowly took the glass and put it some other place away from the painting. He said that was not a good place for that glass of wine. That is how I met Marcel Duchamp.

"Once, in a museum, I looked up and there he was and he said, 'Have you seen my painting?' and I said, 'I don't think it is being exhibited, is it?' and he said, 'No, but it's between two partitions somewhere and I can't find it!'

"He had a crazy studio once. It was very large and empty except that at one end he had put a bathtub where he took his baths. And then there was a bicycle wheel above it. Can you imagine? It was so cold and he must have been very cold. That was a strange studio!"

She could be unrelenting about people. Once she mentioned having toured one of Frank Lloyd Wright's

houses with the architect. "He started to build that house and by the time he got to the other end the beginning was falling apart."

On another afternoon the talk shifted to the earlier days in New Mexico. O'Keeffe reminisced at length about some of the Taos people. "Well, you know, I used to go to Taos all the time to see Tony Luhan—he was an Indian and he was married to Mabel Dodge. And you see, we would all be there in her house and if she wasn't there we could take as many hot baths as we wanted, but if she was there we could never have any hot water. She would turn the hot water heater off and we could never have any hot baths.

"Pete was a man who would come to visit and he would have to walk over a mile to get back to his house, and when I was staying there I would let him use a room in the house [one of Mabel's] where I was staying so that he would not have to walk that mile to his house to go home. And then Mabel found out that I let him stay in that room and she went into that room and took every single thing out of it so that Pete would have to walk the mile to his house to go home.

"She thought that every woman loved Tony and she would get very angry when we would sit near him. Oh me, I didn't have any of those feelings for him, but she

would get very upset just the same. She would sit in the room with everybody who was visiting, wearing chiffon gloves. She had very ugly hands and would sit there and wouldn't talk and she didn't want anybody else to talk either and I had so much fun breaking that up; I would always make people start talking and Mabel would be so mad. My goodness, we had a lot of fun. There were so many people there; I don't remember who, that's the kind of thing I forget about these days, but it was something!"

Christine didn't actually meet Hamilton until perhaps a month after she had started taking care of O'Keeffe. It was a Sunday afternoon about three or three-thirty and he came in to get something from his desk. He told her he knew some friends of her children. They talked and discovered they had a number of friends in common. He observed, "Everybody says that I better treat you well!"

In December, some good friends who knew both the Hamiltons and Christine invited them all for dinner. Christine had been close friends with her hosts for years. At dinner, Hamilton's wife, Anna Marie, stayed much of the time in the kitchen with their two children.

Meantime, Hamilton was saying that no one appreciated him when he "did so much for Miss O'Keeffe." He

said nobody did anything for him. "I take care of everybody; nobody takes care of me!" The host very quietly responded, "I think Georgia has done something for you, Juan."

Hamilton said, "Everyone says there is something going on between us. Who would want to jump on old bones like that?"

Ten

If I had been keeping a diary I might have been looking for things that I could put in the diary about Georgia and in the process miss the real experience. I've never regretted that decision. Any notes I took were sporadic, or very occasional, and sometimes I wrote down conversations that were particularly amusing or, in one case, significant. I have distinct visual memories of her moving, abstract sequences of motions of her hands and the way she would move her face or how she would shift her hips in order to get into a comfortable position. Things like that could never be described adequately in a diary.

For the same reason, I was not in the habit of asking any questions that were prying, on general principles. I would question, within a conversation that she had begun herself, but my intention was to be responsive, not to lead her. The personal information that I did get was the information that she wanted to talk about, that she brought up herself.

We have a tendency to misinterpret greatness. It is revealed

in small motions as well as in large motions. To assume that O'Keeffe's quality came only from a talent that was extraordinary and different from the talent of other artists or that she had breaks and therefore will go down in history as being great is a mistake. Greatness is something that courses through the whole being and through the existence of a person with every breath. Because O'Keeffe chose to paint, it showed up in her painting. However, it was present in the deliberate way she walked across a room or moved her hand or closed the skirt of her very simple black dress. Surface is illusion, and what was coursing through the substance of her being was what counted. And this is what interested me about her, because she had such a strong public image. I tried to find out what was surfacing and how it was surfacing. This is what I do in my own art work, and this is what interests me in life.

I am fascinated with the process of what is just before it surfaces and before it becomes visible. The examination of that process consumes my time and my awareness. O'Keeffe was a particularly appropriate woman to be in the presence of with that in mind. It made me question what greatness is. Her work was taken seriously in a time when women artists were not, and it did not have to look like men's work or be definable as male or female in order to be taken seriously. There was a feminine sense to it that was apparent and did not have to be hidden.

Miss O'Keeffe

Her sparse talking about her work always gave me the feeling she kept the fact of the actual painting in mind, the "ing" of it, the verb, on a level very present while in the process of doing it. Her attitude about it was straightforward: "That's what I saw. And that's why I painted it." When she spoke about her paintings there was never any philosophical discussion about it with me.

She just seems to be in her paintings, in the use of the paint and the paintbrush and what her eyes must have been looking at. The fact that she was aware was why the paintings happened. I know she planned her paintings and, from what she said to me, that she knew what she was going to paint before she painted it. When it was done, that was that. One of the reasons why I never asked her many questions about art was because, basically, I feel that talking about it has nothing to do with it. And that wasn't what I was there for. I would learn more about any questions that might come up, more about the answer to it just by being with her, caring for her, and being responsive to her. By being responsive, I would be able to tell what she was about; it would answer any question I might raise about art. To talk about art seems to me to be a circling around the stillpoint. Art remains the stillpoint, for it has an existence of its own.

There was a natural sense of humility to O'Keeffe. She was surprised that someone would take the time to see her. "Imag-

ine! Him coming here to see me!" she said to me the day Calvin Klein came to photograph.

I recall standing next to her in front of the mirror while she washed her hands or brushed her teeth and seeing my forty-three years as youthful in comparison, yes, but far less beautiful. Her idea of herself was remarkably free of pretension. Once, when I placed a white shawl over her shoulders she said, "Isn't this a fine one!" When I asked her if she had made it she replied, "Oh, no, I have never made anything."

She was quietly observant, as evidenced by her reactions to small things: a silent smile as I would loosen her belt, or a "thank you," although there had been no complaint that it was too tight after the meal; the intelligence of a movement in her face in reaction to a door opening to let in the warm breeze, or in response to the sound of piñon crackling in the fireplace. The tension would ease in her often-closed eyes, the wrinkles of her face would soften along the strong bones, her lower lip, with which she often led, would relax into an almost imperceptible gesture of a smile, her chin would raise her head very slowly, slightly, elegantly.

Many times I was grateful that what contact I had with her was at a time in her life when my presence would not interfere with her life, but might aid it. So often we would like contact with those whose lives or work we admire, and, if given the opportunity to participate, we do. But the presence of an admirer or student or curiosity-seeker can subtract from

*or interfere with that person's own ability to work, a case of
the observer changing the observed. So the Abiquiu situation
was ideal.*

*Her memory seemed typical of elderly people: being able to
remember things from long ago, but not being able to recall
that the previous Thursday so and so had come by for tea
and crumpets. She didn't seem able to organize time too well;
her concept of time was irregular. Sometimes she couldn't re-
member whether she'd eaten dinner, or eaten lunch, or taken
her pills. She'd ask me if it was time to take them when she
had taken them a half-hour before. Because O'Keeffe had this
weakened sense of time my being with her was an exercise in
being grounded in the present. Sometimes she didn't even know
what month it was.*

*Once when I was walking along an arroyo in Tesuque,
north of Santa Fe, I came upon a large cage with a brown
eagle in it staring out over my head. I was startled to see this
powerful creature so still and within my reach. It seemed to
me that Georgia was as unexpectedly caged and still, looking
out over the heads of those around her, her freedom turned
inward.*

*By the time I came to Abiquiu in the fall of 1983 she was
having some frightening dreams at night. Then she had a re-
curring dream about a gate the following year, about a month
before I left her employ. She would dream of this very long
dark tunnel that she would try to go through. She would get*

to a gate, which she couldn't get open. She kept coming to this gate that couldn't be opened. Sometimes it was a grass area that she had to cross. It was a huge struggle, it was dark and depressing. She turned to me one day, after having had the dream five times, never remembering that she had told it to me before, and she said, "Would you help me, take me through that gate?" She said, very agitated, "Would you please come with me and help me through that gate? I am so afraid to go by myself!" She had leaned toward me and her hands had lost their stillness, their folded repose.

I told her I would do whatever possible to help her go through, and even if I weren't there, I'd be thinking about her. After that she never spoke of it again. She also dreamt that a person was coming down a hall to get her and roughed her up a bit. She had a sense of something imposing there, of large monsters.

Other nightmares occurred in Santa Fe and concerned a blue pig. This series of dreams went on for three consecutive nights. They were very simple: there was a big blue pig that came down in the night making a lot of noise. It went into her bedroom and got in bed with her. There was a lot of noise, and she was very disturbed by it. She didn't like what was going on, felt that the pig was very greedy and was taking things.

Eleven

While in Abiquiu, Christine saw how restless Georgia was without Hamilton. O'Keeffe was clearly dependent upon him and she seemed to love him, that much was obvious. She brightened up when he came around.

It is understandable that he would want his weekends free. He had a family to care for and a life to live. The necessary distancing was unsettling to O'Keeffe, however. She wanted to call him on the telephone very often. She would start in the morning when she woke up by wanting to call him to ask if he was going to come over to take her for a ride. She was always wanting to go to Ghost Ranch. "Well, maybe Juan is going to come today and take me for a ride to Ghost Ranch," she'd say.

Christine would try to tell her that she didn't think he was going to because he hadn't given any indication

of it. O'Keeffe would say, "Well, I think we should call him."

At first Christine felt like protecting Hamilton because it seemed that O'Keeffe wanted to be taken for these rides more often than not. She thought it must be driving him crazy. It was obvious to her that he must want to be home alone on weekends since she believed he was there at O'Keeffe's all week long.

But as O'Keeffe was very insistent on getting in touch with him, Christine would eventually give in and dial the phone for her. This would happen several times a day, and then O'Keeffe would be very angry that he hadn't come by. "You told me you were going to take me for a ride to Ghost Ranch," she'd say. "Are we going to go this afternoon?"

Christine could hear him on the other end because the phone was one of those for deaf people; his voice was audible to those nearby. "Stop calling me, Georgia," he'd say. "I am not going to take you for a ride. I'll take you for a ride some other time." O'Keeffe would be very disappointed after such phone calls; they didn't fulfill what she wanted from him. Then she would ask Christine if she could take her for a ride. There was a white car in the garage, and O'Keeffe knew where the keys were. She told her where there were keys to this

and that, and asked her to go look for them so she could take her for a ride. Christine decided it wasn't such a good idea to take O'Keeffe for a ride even though she was her employee and the idea appeared harmless enough. "Miss O'Keeffe, I don't think we had better go," she'd say.

One time O'Keeffe answered, "Well then, he should take me, shouldn't he?" And then she fell silent. Other times she'd try to give Christine directions. "Well, you go down on the highway and then you turn and there's Ghost Ranch." She said it was something like eighteen miles. "You turn and then you stay on that road and it takes you right to the house! It's very easy. Don't you know where it is?"

Christine had not been there and assumed it wasn't as easy as all that to find the place. O'Keeffe was very surprised that she had never been there. "Haven't you ever been to Ghost Ranch? I have the most beautiful back yard in the world in Ghost Ranch. You look out and you see the cliffs and that's all! You never need to see more beautiful cliffs!"

Like many older people, O'Keeffe was very aware of the weather and what it meant to her. She would be very concerned about whether it was going to be warm enough for her and Christine to take a walk. If she felt

chilly indoors, even if it was a nice day outside, she would interpret that to mean it was going to be too cold to walk in the driveway. She would often ask Christine to please go outside and see, even if Christine had gone back and forth from the studio to the kitchen several times already. She would usually want to put a coat on just to make sure she was warm enough.

O'Keeffe would be concerned even if Christine was merely crossing the yard to go to the kitchen. She was usually cold so she assumed that Christine was cold too. If she had just come back from the kitchen and had to lift O'Keeffe or touch her for some reason, O'Keeffe would detect her cold hands. "Oh you are so cold!" she'd say. "Now before you do anything else, go into the bathroom and turn the hot water on and then put your hands underneath the hot water. If you leave them there long enough, the warm water will warm your hands and your hands won't be cold anymore." She was specific about each step; she organized each step in her mind as she talked.

Curtains were closed in the early evening, way before they needed to be drawn. For Christine, this produced a sense of confinement; it would have been so splendid to look out and see day wane, or stare into the dark of the hills. "We have to draw the drapes in the

studio," O'Keeffe would state, very concerned about it. She had told Christine there had never been an intruder, but about four or five in the afternoon she would want those curtains drawn. She wanted them drawn before Christine went out to the kitchen to fix supper. It made her feel claustrophobic because the view was so expansive and beautiful and at four-thirty and five there was still light in the sky.

When O'Keeffe went to bed at night she would ask, "Now, have you locked the door? Have you closed the inside doors across the glass ones?"

She would ask if Christine had checked on the dogs, Inca and Chia. Were they in? If she heard a dog bark, she would ask if it was Inca, her older chow. She was very concerned about her immediate environment when she was ready to go to sleep. There was a door leading to the outside in her bedroom which she always had Christine check to see if it was locked.

If the dogs were outside and she heard barking, O'Keeffe would ask Christine to go check. "There must be someone coming to the gate. Go to the gate and see if someone's coming because Inca is barking." Sometimes, Inca would hover around that outside door of O'Keeffe's room. Inca was a dark-colored chow; Chia was lighter and not so well-behaved. Chia had replaced

an older chow O'Keeffe had loved very much, a companion to Inca. Chia would eat Inca's food and she was much more the barker at night so the two of them would be brought into the studio for the night. That was one of Christine's jobs, to round up the two dogs before they settled in for the evening. However, once they were in, Chia would decide to start barking; she'd bark for no discernible reason in the middle of the night and do it periodically thereafter. Christine would decide to let Chia out finally so she could find whatever it was she was barking about. All these goings-on didn't seem to bother O'Keeffe asleep in the other room, but Christine would worry that Chia might go bark right outside her window and wake her up. So, after a while, she'd let the dog in once again. Sleep wasn't easy under these circumstances: O'Keeffe had her whistle and Chia her importunate bark.

Twelve

Christmas came. It was about that time that Georgia told me to call her by her first name. Talking about names, she said that Christine was such a beautiful name. This was when she finally stopped calling me Chatterley. She said I was lucky to have a name like that. "Can you imagine? They named me after a man. I have a man's name! Can you imagine naming a baby girl after a man?"

Christmas in Abiquiu proved to be a very long and demanding weekend on the one hand, and a particularly interesting and special one on the other. It was a long weekend for me. The week before, Georgia and I were discussing Christmas and going through little boxes that had been stored underneath the sink in the studio. We talked about what to do about the holiday, and she was very concerned that I wasn't going to be home for Christmas with my children. None of the other women could work because they had small children. I had asked my

sons, who were all grown, and they didn't mind. I would be back the following day.

She was very quiet when I told her I would be with her on Christmas. She just stopped talking and didn't say anything. She thought of my sons and said, "Well, it wouldn't do to have them for dinner in the dining room, so we should have them for dinner in the studio. They could come and have dinner in the studio and then you would be with your children on Christmas."

None of my sons ever met Georgia. Looking back, I wish I had made another attempt because I think it would have meant something to her as well as to them. I didn't know I would be gone within a year.

So I told Georgia that Hamilton had already said, "That's not a very good idea." She got very quiet again and a little while later she started talking about it once more, how they could come to the studio and we could open our gifts in the studio while she was in the dining room with the Hamiltons having dinner. I was touched by the graciousness and sweetness of the thought, but knew it wouldn't work because I would be in the main house serving and caring for her. Besides, there had been snow and the road from Española was slick. I did not relish the thought of all four of my sons tackling that road on Christmas, all in the same car.

She said people used to come to her home at Christmas time.

Miss O'Keeffe

Sometimes the neighbors would come; she knew them all. "Now all that there is at the dinner table is Juan and that girl and their children."

"My friends have gone to get a Christmas tree," she told me. "They have . . . not a wagon but just a good thing to carry a Christmas tree in."

We were going to decorate the tree. She was trying to remember what she had that would make good tree decorations. With her usual sense of exactness she told me where to look for some shells she had and exactly how they would be wrapped; that they would be in a certain kind of box with a certain kind of string wrapped around it and that it was on top of another box in the cabinet underneath the sink.

We spent a lovely afternoon going through boxes of her treasures, boxes of shells which she would feel and tell me where they had come from. She wanted me to make some tiny paper sculptures like bigger ones I had been making during the night. I was using good Italian drawing paper and she had responded to the sculptures, seen the whiteness of them. I had scored them into wavy lines on alternate sides and bent the paper so there were lots of shadows, which she could see.

She sat there feeling them and said, "I want you to make some very, very small, just like these, and then we will put a string in them and hang them on the Christmas tree and that will be one of the decorations." There were other decorations

she was looking for in her boxes but when we couldn't find them she decided they had been given away. Perhaps Hamilton or Pita had given them away, she suggested.

She picked up a small black stone from a table near her chair. She felt it for a few minutes and said, "Perhaps we can put this on the Christmas tree." She thought about it and added, "No, that won't work, I suppose, because there'd be no way to hang it." She fingered the stone again and said, "I could give you this for a Christmas present because I don't have a Christmas present for you," adding, "There is a particular way that you can hold it in your hand and your fingers fit it perfectly." She handed me the stone and asked, "Do your fingers fit it perfectly that same way?" I held it and found a way that my fingers fit it, and told her yes, but I didn't know if it was the same way she held it. She said that would be my Christmas present because she couldn't get to the store to get me a different one.

To think of her getting to a store to buy me anything was a wonderful image. She wanted me to go in to Bode's General Store in Abiquiu and buy something for the children, some candy canes. She said children liked candy canes on trees. Or perhaps go to Española so I could get some jackets for them. Later on she said, "Well, I suppose we won't have to do that." When I went to Bode's to get the incidental supplies for Christmas dinner, I followed the usual procedure of charging them to

her. The young boy at the counter questioned my authority to do so, and exclaimed, "O'Keeffe eats candy canes?"

Hamilton told me he would be cooking Christmas dinner, that he did everything so I didn't have to worry about that. Then Pita took me aside before she left and said, laughing, "Oh, yes, you do. What he means when he says he cooks Christmas dinner is that he comes Christmas morning after you have stuffed the turkey and he cooks it in his oven and then brings it back. That's what he means by cooking Christmas dinner so you need to do everything else." I cooked for two days. I made rum cake and bread and other holiday foods. They were just coming for Christmas dinner and I was to have it ready. It took me a couple of days to do it because it was done along with caring for Miss O'Keeffe.

After returning from making the rum cake in the kitchen I told Georgia what I was doing and she said, "Well, maybe before bed I should have a glass of rum. I used to do that after I'd been painting. When I was finished painting at night and I'd clean up my brushes I would have just a little glass of rum right before I'd go to bed."

We had dinner in the afternoon. I hadn't planned to sit at the table but I was asked to do so. I had already served them dinner when Anna Marie told me, "Pull up a chair and eat with us."

With the Hamilton kids, who were ages three and five or

thereabouts, and who came for dinner and then left, O'Keeffe was polite. She gave them attention if they were in the same room with her for very long. They were very active children; they had enormous amounts of energy that had to be spent each minute and she would laugh with them. They called her Georgia and were fond of her.

There were presents for her from everyone and, somewhat detached, she opened maybe one on Christmas Day; the others she opened several days later. Christmas wasn't a big event except for the dinner. I had set a lot of candles around the table, lots of little votive candles; the dining room looked beautiful. The fireplace was lit and the warmth of the adobe room was very comforting.

Georgia was finished with dinner before the rest of us and wanted to go back to bed. She never did eat very much. She always ate small portions of everything, like a bird usually.

Hamilton decided to put Miss O'Keeffe to bed himself, and came back to the table. I was nervous about leaving her in the studio alone. We were having dessert, Hamilton talking about business and employees. Anna Marie brought me a funny little tin clown; I thought it was a sweet gift.

After he returned, and we all talked for a little while over a glass of wine, I made an effort to get up to go check Georgia. Hamilton felt it wasn't necessary and told me not to.

I was exhausted and nervous about getting back to the studio

Miss O'Keeffe

so I later cleaned up about half the kitchen and then went to check on her. She was sound asleep, fully dressed, on top of her blankets.

When I took Georgia to the bathroom later that night, I changed her into her nightclothes, but she was never quite awake. She thought she was talking to someone besides me when she said slowly, "Now I want you to go and help Christine; she's been working for so many days and she doesn't have her children with her on Christmas. I want you to go and help her clean up so she doesn't have to do it all."

Thirteen

Christine would prepare the noon meal and go over and bring O'Keeffe to the dining room. O'Keeffe would usually want to put a coat on; then the two of them would walk across the courtyard and go in directly through the kitchen. Christine would help her sit down at the dining room table, where she would sit very erect, with something very formal about her. She would sit and immediately take her napkin and place it very neatly across her lap.

Christine had everything ready and O'Keeffe would have her soup right away. She would spoon out the soup very quietly and carefully; she would drink it out of the side of the soup spoon and set that down on the place plate underneath it rather than in the bowl when she finished. She had impeccable manners in everything. When she ate she would incline forward slightly with a very straight back. She would lower her head and

would appear to be looking down at the plate but she would not be hunched over. Eyes followed hands and she would eat very slowly and in absolute silence. She would lift the food with her fork and, facing straight ahead, bring the fork up and put it in her mouth very meticulously, very exactly. When she was finished with her meal she would fold the napkin ever so carefully. There were no wasted motions.

She would usually suggest that Christine sit down and eat lunch with her. She would only join her some of the time, depending on how much of the meal needed looking at in the kitchen while O'Keeffe was eating her soup. She liked to have her salad after the meal. When O'Keeffe insisted that she sit down and eat with her, Christine would sit down and eat something so she could have her wish.

O'Keeffe would say something about the food, often commenting on how good it was. She'd say, "Well, you certainly went to a lot of trouble," or "Thank you very much, this is delicious," or, "I don't much like such and such," if Christine had given her something she didn't really like.

She was pretty involved in eating. It was work for her to eat and it would take her at least half an hour to finish her meal.

Miss O'Keeffe

While in Abiquiu, Christine didn't have to help O'Keeffe much with eating. She'd prepare the meal in such a way that a knife would not be necessary. As mentioned before, when she first went to work she was told to feed O'Keeffe whatever leftovers were in the fridge, but the food that was left from the week never seemed appetizing enough to feed her as far as Christine was concerned. She started to get inventive with what was there, and to ask for special things. She asked Candelaria to make sure there was a little more food left with them than before, preferably fresh vegetables. She talked to Pita and to Hamilton about it also.

One typical lunch hour that Christine recalls began with O'Keeffe, cane in hand, taking Christine's arm and crossing the outer courtyard. O'Keeffe bundled up since it looked like snow.

Christine had prepared a steak for her, and had begun a fire in the corner fireplace in the dining room. She closed the outside door quickly behind them, as the bread was still rising and O'Keeffe was worried about the draft damaging the rising. On this day, Christine had not set a place for herself because she hoped the bread might be ready for a second kneading, but it wasn't. "Sit down and have your dinner," O'Keeffe said. Christine joined her, happy to be in that particular

room with her. O'Keeffe was usually quiet while eating, deliberate about the process, fine manners ingrained within her. At one point she put her fork down and stared over Christine's head. She said, "I used to make bread in the morning and then in the evening we would eat it, when it was warm. It makes me laugh to think that here we are today making bread in the morning in this kitchen. That's a surprise, I think that's a fine surprise to make bread in this kitchen. I don't suppose that it's ready to bake, is it? Well, I suppose not." She picked up her fork again and began eating her potatoes. Christine told her that it would be a few more hours, and they would have an afternoon snack of nice hot bread.

Christine thought back to the first days in Abiquiu, in the fall, to the first time she fixed a dinner for O'Keeffe and smiled. She had served a steak to her that first time, and had sat down across from her, not eating, just being present. "Well, get the sauce!" O'Keeffe had snapped. Already nervous and not yet comfortable in the job, Christine had hurried into the kitchen after asking what kind of sauce she wanted. "The steak sauce!"

Searching frantically through the refrigerator, she found no steak sauce, so had to go back and ask where it was kept.

"In the refrigerator, of course. You know, Candelaria's steak sauce!"

She ran back and forth several times, checking everything in there that remotely resembled steak sauce, including some Señor Murphy's red chile jelly. Her heart racing, Christine felt sure that this was it, that O'Keeffe was finished with her. She sat down at the table again. "Miss O'Keeffe, how does Candelaria make it?"

"Why, she just makes it up in the kitchen. I think she chops up tomatillos and other things and then she cooks it. Don't you know what steak sauce is?"

Christine made one last attempt to solve the puzzle, bringing back an odd-looking mixture in a yogurt cup and giving it to O'Keeffe. "Well," she said, "why didn't you bring this to me in the first place?"

After the meal Christine would take O'Keeffe back. She always had her cane with her, a very old cane that had a gnarled knob for a handle. They would head back to the studio and O'Keeffe would go to the bathroom and brush her teeth. She would wash her face, Christine would take her shoes off, and O'Keeffe would actually slip into her bed to sleep. The nap lasted perhaps an hour, sometimes more. If it was a warm day, Christine would have taken Georgia's dress off so she'd have to slip into it again, later.

Miss O'Keeffe

An annoyance when Christine got there on Fridays was that there often wasn't enough dog food in the place. She'd have to leave O'Keeffe alone for a few minutes, and drive down the short distance to the Abiquiu store to get some for the animals. Or there wouldn't be any laundry soap. Since she always stripped the beds and did the laundry before she left she would have to make sure she had enough soap before the weekend.

O'Keeffe wasn't allowed to have salt. On the other hand, she got away with half a cup of coffee a day. Her favorite was Medaglia D'Oro espresso and she had it shipped in from New York. According to one of her friends she "smoked like a smokestack" at one time in her life but she never talked to Christine about it.

She told Christine once there was a Penitente *morada* (house of worship of the Penitente sect of New Mexico Catholics, known for their zeal) at the end of the road. She said it was a very fine *morada,* quite beautiful. "You must go up and look at it," she said. She would speak of something like that and then grow very silent. She would retreat into thought and sit silent for a number of minutes. Then she might say something else about what she had said, as though she had gone back to the actual event and was experiencing it again.

One day, walking in the driveway, she talked about

her sister whose husband and child had died. She talked about God and told Christine that she used to go to church a long time before. She said she wasn't much up for that kind of thing any more. Another time she said, "One of my friends just passed away in the middle of the night. I thought that was a pretty gentlemanly thing to do. It was pretty neat. He's under the daisies."

It was a frequent ritual in Abiquiu for the two of them, who were about the same height, to go walking outside the house. O'Keeffe would leave her cane by the gate and they'd walk, arms intertwined like two school-girls. They'd go round the compound seven times. The weather would be crisp and sunny; those autumn after-noons that bring the smells of wood and *piñon* fires in the breeze. The walkway would be full of fallen leaves, which they'd crush as they walked. O'Keeffe would be wearing her quilted black silk coat, black gloves, a scarf over her head tied behind to keep her ears warm, per-haps her *gaucho* hat on top. A few cars passing along the road would slow down to look at Georgia O'Keeffe performing an everyday activity.

On one such walk they spoke of religion. Christine asked her what she thought of God. "I don't think much of God," she said. Wondering exactly what she meant, Christine asked for clarification. "I mean exactly what I

said: I don't think much of God!" She left Christine to decipher the ambiguity but a glance her way told the younger woman O'Keeffe was enjoying her having to do that.

On the rare occasions when someone was going to come over and visit, O'Keeffe would be likely to say, "Well, I suppose we could get dressed up for this affair." She was very particular about her clothing but she didn't talk about it except when getting ready. Then she'd ask for a specific pair of gloves that she wanted to wear, or a particular pair of shoes, and she'd tell Christine where she would be able to find them. One time she had Christine looking for a cape and directed her to look in some boxes behind the muslin curtains in the far end of the studio. When Christine wasn't able to find the cape, she had her call Pita at home to see if she remembered where it was. They never found it, and O'Keeffe concluded that it had been given away to someone.

She had wanted to wear the cape to a memorial rosary for her friend Frank, the fellow who had died so conveniently in the middle of the night. He had been a neighbor who had helped her stretch the canvas for the cloud painting that is now in Chicago. When she heard that Frank had died—and he was considerably

younger than she was—O'Keeffe told Christine that he had always helped her a lot and had come over and done quite a number of things for her over the years. They were sitting near the fire in the studio; it was a cold day and O'Keeffe had felt like reminiscing. But she got very quiet then and added, "Why I never thought of Frank being dead. It's very hard for me to think of Frank being dead."

She said Frank was a very good friend to her and she was distraught that day. It wasn't that she was nervous. She sat silently for a very long time with her feet in front of the fire and about every five or ten minutes she would say something else about him; she would bring it up again. It was on her mind and she didn't say a lot, but what she did say was about that man. She mulled it over for a very long time. She didn't cry; Christine never saw her cry but she saw her confused and hurt by that death.

Another significant death was that of Ansel Adams. Hamilton came into the living room in the Santa Fe house where O'Keeffe was sitting in front of the fireplace and casually said, "Georgia, Ansel has died." Without hesitating, O'Keeffe replied, "Oh yes, he didn't take good care of himself, did he?" She never spoke of that again.

Miss O'Keeffe

She cared about politics sporadically, as many artists do. When Walter Mondale picked Geraldine Ferraro for vice president and Christine told O'Keeffe about it she said, "Well, let's get out and vote then!" She wanted to get other people to go and vote, she thought everyone should vote. She said she'd have Hamilton take her to vote for Geraldine Ferraro.

Getting to look "spiffy" was something she liked. Christine would spend a lot of time on her hair, something O'Keeffe loved. Once when Christine was helping her put on the winter silk underwear, she told Christine that she remembered when she was little, her undergarments made her itch, and that these were a pleasure. She was fond of a lovely white linen kimono and every now and then they would decide it was time for her to wear it.

"That's very fine," she would say, "that's very fine," in everyday conversation. Another expression she was fond of was "industrious" or else "inventive." "Well, that was a very inventive breakfast," she would say, or, "My, aren't you industrious to make pancakes this morning!"

If she was in a down mood she might say, "Well, I suppose I should go sit in a chair." The day's routine would be punctuated by such remarks, or by, "Well, I

suppose it's time to put my feet up," or "Do you suppose it's time for dinner yet?" If she wasn't hungry she'd say, "I don't much care what we have for dinner."

If something happened that was a fit subject for a little homespun philosophy, one might hear her say, "Oh dear, well, that's life." Most times, however, she spoke most precisely. She used nouns rather than pronouns and would specify an item by its color or location. Her voice had undergone changes; it had the tightness of age. It often tended to be scratchy and small, the kind of voice one hears in nursing homes or the geriatric wing of a hospital, but this voice alternated with a more conscious and smoother, a more relaxed, voice.

Her speech was deliberate. She used few words and would speak quite slowly, pausing in between words and phrases. The times Christine wrote down her conversation she had no difficulty at all writing it as O'Keeffe spoke.

Often, her voice would have a pleading sound to it, a supplicating tone beneath which lurked the fear of being abandoned. If Christine walked across the room she might look up and ask, "Where are you going?" or "Why aren't you here with me?" in a high-pitched, old woman's voice. Then, when Christine explained what she was up to, O'Keeffe would say, "Oh, I see," and she

Miss O'Keeffe

would be all right. But she was likely to be taken aback by behavior that didn't make immediate sense to her. Then her voice would be rather plaintive, like that of a child who is afraid her parents are going out for the night and won't come back.

Christine puts it very well when she says, "She was fragile the way only O'Keeffe could be fragile."

Fourteen

The quiet repose of her hands, one over the other, magnified the presence of the power within. The bones protruded, revealing memories of their many years, a life of painting, yet her hands seemed undecipherable and enigmatic, as if waiting for some new movement.

The coloring of her hands was translucent and sometimes almost lavender. They were very long hands with liver spots and large veins. I like to look at Stieglitz's photographs of her hands when she was younger because they were still the same when I knew her, only aged. The photographs show the same gestures. She kept her fingers together; the last three fingers would bend in unison as she lifted her hand up. When I took her to the bathroom to wash, she had a gesture with her hands. She kept her fingers straight out, not really moving them; she would use her whole hand in a kind of wafting motion and that way splash water on her face.

There wasn't much articulation to the individual fingers

but she used her hands often in wing-like motions. She moved with relative ease and there was even a time when she started doing exercises. I would lift her hands over and over.

All the nurses were instructed to do that. The exercise was to lift her hands above her body in an airplane fashion, then swing them down and up over her head, down and around and up. She loved it. She would start to glow and her face would get flushed; she would laugh, delighted with the movement. A childlike look would come into her face. She always said yes when she was asked if she wanted to exercise and she told me that at one time she had done a routine of exercises every day designed for a person to keep in shape, designed, in fact, for her by "a famous woman," as she told me, "before she was famous," whose name was Ida P. Rolf, emphasizing the P. with a laugh.

Her movement as we walked outside was really as if her bearing and the power within the earth were one and the same. It was simply made visible by the nature of the terrain; it was brought forth from beneath and appeared as if unseparated from the motion of the universe itself. Nor would I have been surprised if I had been told that her own movement preceded the groundswell, that the trees swayed in response to her, that the roar of the autumn sky above was an elaboration of her own.

Art has nothing to do with paintbrushes or ink or graphite or any of the materials that are used to create it; those are just

used in the attempt to make the transition from the spiritual to the physical and back again. The magic that is sometimes present in what we call art has nothing to do with those materials. It may have to do with passage, with something made visible by one human being to another. We do existence a great disservice by having to reduce art to a material plane, to painting, drawing or sculpture.

Georgia and I discussed the differences in our approaches to our art work. She said that she knew ahead of time what she wanted to do and then did it, working out problems as she went along, but basically starting in one place on the canvas and ending in another. I tend to work all over the surface at all times, bringing the images through from within. My images form as I work in response to the process. When she sat at the table one day drawing on a sheet of paper, a few lines only, she said it was a new way to try something, without an idea ahead of time.

I had suggested to her to try it out even though she could not see much, just shadows, thinking her discouragement that day might be softened by the act of drawing, since we had spoken of her love for the process. She had lost her central vision when she was in her eighties; it had happened rather suddenly just before she met Hamilton. I believe she continued to paint, but by the time I took care of her she had stopped.

There were times when I would look at Georgia and for

a microsecond would experience the difficulty of not knowing whether, in her stillness, she was fading out of existence or appearing for the first time in this world. There was this sense of translucence sometimes. It was like a symbol for the moment of transition, what T. S. Eliot talks about in Burnt Norton, *where the dance is:*

"Neither from nor towards; at the still point, there the dance is . . ."

She wasn't completely blind; she could see shadows. And there were times when she could see more than at other times, perhaps because of the quality of the light. Sometimes she'd ask me what the moon looked like or ask me about the clouds. Once when we were outside walking she looked up and said, "Well, I see there are clouds in the sky." She could see the movement of things and large patterns.

On her dining room table there was one of her sculptures. It was white, eight to ten inches high, and it looked like a maquette of the very large bronze that ended up in the yard in Santa Fe while I was there. There was a larger version of the maquette in the studio. She told me that whenever she had a painting that she wasn't sure about she would put it next to that sculpture and if it looked all right with it she would know the painting was good. When I asked her when she had

*done it Georgia couldn't remember but, according to her, it
wasn't done in clay at first. And she told me, "If whatever I
painted didn't stand up against that I knew it was wrong."*

I asked her if that happened much.

"Oh, I don't think it happened very often," she grinned.

*Two of her later paintings were in the studio: a lot of sky
and a little bit of land. I doubt that they would be considered
among her best paintings. My understanding is that her sense
of color had changed by the time she painted those, that she
had help. They were paintings from the last ten years, I was
told, after she had trouble with her eyes. But there were other
paintings in the house. There was one in the living room, one
of the flower paintings, that was quite powerful.*

The only paintings she talked about much were Jack-in-
the-Pulpit #5 *and the big cloud painting. We were discussing
my drawings—this was in Santa Fe in the summer of 1984—
and we were talking about the Vietnam Series that I was
doing. I showed her the one I was working on at night while
taking care of her and told her that the main one would be
twelve feet long. So the large cloud painting came up and the
story she told me was almost exactly the one that was told in
the big book of her paintings. About how her friend Frank
helped her stretch the canvas in the garage and how she kept
looking around to make sure there were no rattlers.*

One thing she said about Jack-in-the-Pulpit *was that*

other people tried to make other things out of it but that it was what it was, a flower. "I had to work very hard on that painting to get it right, to get it simple."

When people asked her did she miss painting, she'd tell them, "Well, what makes you think that I am not painting anymore?" She told them she was painting inside her head, that she could still see colors inside her head. The only advice she ever gave me was, "Never let them keep you from doing your art work!"

Fifteen

Everything comes to an end, even the triumphal seclusion of an animal or an artist. The fact that neither Christine nor O'Keeffe had any inkling that the Abiquiu life was rapidly drawing to a close makes those last days there all the more poignant.

Winter had come. Walks outside were impossible unless the weather turned unseasonably kind. The fires were constantly going and life was lived closer to the bone.

When Christine told O'Keeffe her business had been sold and that she would be free after December, the first thing O'Keeffe said was, "Did you tell Juan? Now you can come and work every day. You must tell him. Let's pick up the phone and call him and tell him that your business is sold and that you can work every day now!"

Christine told her she didn't think she could come every day because she needed to do her art work.

O'Keeffe replied, "Well, I suppose I can understand that. But maybe you could do your art work one day a week and come here and work the others." Then she had another idea: she said, "Oh, now you can take me out to Ghost Ranch!" That was when she started asking to be taken out there for a week or two. She talked about that for a long time but it never happened.

One of the reasons why later, in April, Christine consented to work full-time was that she knew she could do some drawing while tending O'Keeffe, but more importantly, after her return from seeing a sick friend for whom she could do nothing, she was aware more than ever of the privilege of being able to help O'Keeffe.

O'Keeffe seemed to like telephones. In Abiquiu, of course, she had one in her studio. She would brighten up when an old friend would call her. Unfortunately, there weren't many instances of that.

Other than such rare interruptions the silence in Abiquiu was all-encompassing. It stood for the distance from the world that Georgia O'Keeffe had always sought and valued. It was a silence that taught one not to complain. Christine heard O'Keeffe complain about things very rarely. She seemed to be able to live as life required it, moment by moment. One morning, yes, O'Keeffe woke up feeling despondent and she

complained. It was a good complaint, solid enough to make up for long periods of stoic silence. She was sitting in a corner of the bedroom; Christine was getting her dressed when O'Keeffe said, "I don't know how I can get through another day and I don't know why I have to!"

She had been having a lot of trouble sleeping, being up a good part of the night. Exhaustion may have had something to do with the complaint. A number of times she would decide she wanted to come into the studio and so Christine would get a wrapper for her and she would sit on her white chair near the bedroom door. Christine would stop drawing and the two of them would sit and talk. Then, after a while, O'Keeffe would go back to bed. One time they decided to have some camomile tea and Christine went across the compound to the kitchen to make it.

It was quite late at night, it was winter. Only two women awake for hundreds of miles, secretly concocting a ritual of the utmost simplicity, boiling water, steeping the fragrant plant, drinking it for its unknown benefits . . . It wasn't that she wanted everything to be kept secret; she was, after all, a very public person. She allowed herself to be photographed, to be interviewed, she exhibited her art, the most personal thing about

an artist. But that Abiquiu distancing, that aloneness in the immensity of sand and cliff and night was for the protection of her consciousness, for the focusing of her attention and for the development of her thought and sensibility. It wasn't meant to turn the world away on its own terms but on her own terms. When she did allow something of herself to be known it was always on her own terms.

Once during that winter O'Keeffe had to go see a doctor in Española. Christine remembers her being helped into the back seat of her white Mercedes sedan by one of the Lopez brothers—probably Mino—and by Pita. They placed a pillow against the side so she could lean in comfort. O'Keeffe was dressed in a long black wool coat and had a shawl placed over her lap. She had one leg up on the seat and looked very cavalier, elegant, like a queen being escorted about her land.

In March, a trip was approaching. Hamilton was taking her to Palm Beach, to visit her sister. She would not be the same afterwards. During that hiatus, Christine would go to Washington state to visit a friend. She would return to find her ward resettled in an uncharacteristic mansion in Santa Fe.

Sixteen

During January and February I substituted a lot. Our relationship couldn't have been better; I understood her needs and provided the companionship she needed. We had grown fond of each other. Then, in March, Hamilton took Georgia to Florida to visit her sister, Anita, and I went to Washington to visit my friend who was very ill.

When I returned they had moved to a big house in Santa Fe and were hiring twenty-four-hour nursing care for the first time, from a service in town. I was now available to work full time and Hamilton seemed pleased with the idea. He and his family were now living with her, and he felt a lack of privacy with the constant turnover of nurses from the service.

Their return from Florida had been quite sudden. Hamilton said Georgia had taken ill so he had chartered a plane and brought her back directly to St. Vincent's Hospital in Santa Fe. Georgia told me that Hamilton had an argument with her sister over some paintings as well as other matters. She said,

Miss O'Keeffe

"They never really got along very well, but this was a particularly loud fight. And the next thing I knew I was being put on an airplane and taken away."

Georgia was in the hospital for a short stay. This is when a cardiologist started taking care of her. While she was there, Hamilton bought the big house in Santa Fe. This meant that Georgia was not to live in Abiquiu any more.

Pita suggested I work full-time, instead of just weekends, in order to simplify the nurses' schedule and provide continuity for Georgia. A registered nurse from Abiquiu was working nights so I worked days, six days a week. At first it was a straight eight-hour shift. Then, after a week, someone could not come, there was a shortage of nurses, and Hamilton asked me if I'd be interested in working double shifts. The work was not hard physically; it took endurance but it was not difficult to work sixteen hours. Besides, I was used to long hours. So I agreed to try it and see how it worked. I was to have an hour or so in the middle of the day so I could go and exercise at the gym. Anna Marie or one of the men in the yard would then take care of Georgia during that time. Soon, I was unable to take the break. Hamilton said that Anna Marie didn't like the idea and he couldn't take the men from outside.

When I went back, that first day, we had not seen each other for a month, Georgia and I. There was a male nurse by the bedside, on my side of the bed as I walked in the door, and

Miss O'Keeffe

Anna Marie was on the other side. Pita showed me into the room and said, "Miss O'Keeffe, Christine is here." Georgia tried to raise herself on the bed and said, "Oh, that's the best news I've heard so far." Anna Marie looked at me with a great big smile. It was gratifying to be back with Georgia again.

Seventeen

The house in Abiquiu revealed the soul of O'Keeffe, whereas the Santa Fe house seemed to discount what she was all about.

The concordance between O'Keeffe's rhythm and her low adobe buildings, the quietness of the black door, the placement of the garden, were of a breath with her own being. There was no conflict between the land and the forms of the rooms. She had been inseparable from the forming of that simple house; it had an intimacy and a sense of humanity that carried the voice and stamp of her personality.

In contrast, the Santa Fe house was a large, imposing affair, looming up away from the land rather than being of it. It had a number of garages, studios and guest houses here and there over the grounds. It was a house unlike her spirit; there was a sense of awkward-

ness in the organization of space. Its forms lacked the grace of the Abiquiu house, which seemed to reflect O'Keeffe's presence. The Abiquiu house had grown congenial with age in the same way age had made O'Keeffe more exquisite.

Even the furnishings were alien to the unassuming way she had furnished her own house in Abiquiu. The huge lawns, the sculpture garden and the fancy Manhattan look of the living and dining rooms seemed a world away from the earthiness of O'Keeffe. Although the furniture was beautiful (glass and leather in order to resemble a New York loft, Christine was told), it wasn't at all like her house in Abiquiu; she was a stranger in it. The living room was a grand hall, almost.

It was a house full of echoes, a hollow investment; sound imposed itself from one side of it to the other, ringing across and bouncing from the living room ceiling. There were rumors that it was haunted, and people talked of seeing faces appear in the windows.

In Abiquiu it was clear that this woman had striven to live in utter simplicity, in complete union with her surroundings, and that she came close to having no extraneous matter around her. Some of her things reappeared in Santa Fe but they were like outsiders, strangers.

Miss O'Keeffe

The bedroom allocated to O'Keeffe was some twenty by fifteen feet, on the ground floor. Her bed, brought from Abiquiu, had an electric device that could sit her up. She often lay on it with her head slightly raised by two down pillows which Anna Marie purchased for her when they came to Santa Fe.

O'Keeffe disliked the wicker couch that had been placed in her bedroom; she complained about how much it creaked. O'Keeffe could not be comfortable on it. She would not sit on it for long, and she did a lot more shifting from one spot to another. She was able to settle down in Abiquiu and find peace for an hour or an hour and a half at a time whereas in Santa Fe she would want to move every fifteen or twenty minutes.

There was no other place in her room where Christine could sit next to O'Keeffe. The other chair, besides one Christine used by a table to draw, was the old white chair they had brought from Abiquiu. It now sat by a window and O'Keeffe would change from the couch to the chair and back again without finding comfort. The couch was the only place to sit together and there they managed as best they could. O'Keeffe would lean over and place her head next to Christine's when she spoke, or in order to hear better. O'Keeffe liked to ask questions about Christine's children, but had trouble

remembering their different names. She ended up referring to all four sons by the name of one of them.

Behind the wicker couch were bookshelves; these were painted white during the early summer while O'Keeffe was moved to a separate apartment beyond the unused hot house at the end of the building.

There were shelves behind the door and these accommodated O'Keeffe's hats. Anna Marie had ordered hats for everyone from an exclusive hat shop in Santa Fe. Although O'Keeffe seldom wore one any more she did sometimes put one on when she and Christine went out onto the long, covered patio, the *portal*.

The closet for O'Keeffe's clothes was in a guest room, because there was no closet in her room. She would have to wait while Christine went to get her clothes, sometimes making more than one trip if she forgot something. Since most of her clothes were merely variations of the same garment, at first only some of her clothes were brought to Santa Fe. Gradually there were more to choose from, and Pita and Christine finally organized that closet.

The bathroom did not have a tub, and this meant Christine would take O'Keeffe to the guest bathroom across the house for her baths and hair washings.

A covered porch extended along the back of the

house. In good weather, when workers and machines were not there, O'Keeffe would lie on a chaise-longue that seemed comfortable to her. She'd wear her hat; Christine remembers tying it on her under her chin. Sometimes they would have lunch there.

The porch looked out into an almost park-like vista with lots of large trees. A round fountain that had been there had been taken out for the sculpture garden. The property consisted of about twenty-six acres altogether, and a landscaping service was putting in an enormous lawn area. The lawn seemed to involve acres and the sprinklers were on much of the time. There were machines everywhere. Far away to one side was a swimming pool where Anna Marie swam with the children. The day before Christine left, Anna Marie's mother was visiting and they all went for a swim, Anna Marie, her mother and the children. Christine sat with O'Keeffe by the side of the pool.

A long studio stood at a distance. The Cates, who had owned the property sometime before, had used that building as an art school. To the left of that was a multi-car garage structure with an office space above it. Farther to the left was another studio, a long low building. A drive extended all the way to what had been the school area.

Miss O'Keeffe

The living room had high ceilings, and in the center of the south wall was a large fireplace with French doors on either side. Leather chairs flanked the fireplace. These were modern and soft. The room was not furnished when they moved in, it was only furnished gradually. There was a large rug with flower and fruit patterns on the floor. A couple of times when Christine was put in charge of the children, they would play on that rug. They would all pretend they were eating the fruit portrayed on the rug—grapes or berries, giggling and laughing and talking about what colors they were eating. She recalls Anna Marie coming in through the front door of the house and laughing when she saw what Christine and the children were doing.

Sometimes she and O'Keeffe would just walk back and forth in that room because it was a nice long walk. But by summer, it became too much of an effort; most walking was done back and forth the length of her own bedroom.

The house was full of people inside and out. Anna Marie had a girl named Agapita who came regularly to take care of the two children. Besides her, there were babysitters from various agencies who came to watch the kids every day or at night when the Hamiltons went out. Then there was Candelaria, who would come to

cook on Wednesdays, a problem because she was getting older and wasn't well. "I am getting kind of old," she'd groan when she'd come in from Abiquiu.

There was an older woman who came to clean on a regular basis, the Lopez brothers working in the yard, plumbers messing around with the plumbing, and cabinet makers renovating the kitchen completely, besides the outfit employed laying the lawn. All of these people made noise. O'Keeffe would complain and complain about it and ask Christine to please shut the windows, she didn't want to hear machine noise. Why were there so many machines? It baffled her; she was irritated and agitated by all the hubbub.

Eighteen

In the beginning, when I first worked for her in the fall of 1983, Georgia was able to walk with her cane in familiar surroundings, slowly and hesitantly. In the next six months I saw a marked deterioration in both her energy level and general health. She had increased trouble with swelling of the left leg and all her problems became accentuated by the time she got to Santa Fe. She reached the point where she didn't want to take walks outside because it meant going down a few steps. It took a lot of encouragement for her to try that. She would hang on very tightly. It was the first time I saw her frightened about walking; she seemed to be losing her confidence in being able to make it, even across a room.

Sometimes when I was helping her into bed, she seemed so weary, so fragile, the thought of her not making it through the night occurred to me. And I wondered what I would do. As a mother I have a tendency to go immediately into a calm,

low gear in a crisis, at least at first. And yet, so far I had not faced death so closely.

Several times in Abiquiu, she had a bout with something or other, once so serious Pita called to say I might not even be going to work that night, although it turned out that I did. On my way to her house, I passed an ambulance on the winding road from Abiquiu, going the other way, and I thought she might be in it. I watched that ambulance get farther and farther away in the rear view mirror, and it occurred to me that someday, she could die in my care.

I've always been fascinated by driving along a road and watching the optical illusion of the destination ahead in the distance seeming to get smaller instead of larger, as I near it. The immediate surroundings flash by on either side of the car, seeming larger, and the contrast fools me—yet only my own location has changed. The point of destination ahead is, of course, actually getting closer, visually enlarging, as it has been all along. The contrast is only in perception.

I wondered if that's how we see old age: something that seems to retreat from our understanding the faster we approach it, the closer we come to it, from whatever perspective. We don't notice that it contains the entire journey, all of the surroundings through which we have passed.

Georgia's ways were changing. I remember the pleasure she had taken in Abiquiu sitting right in the open doorway of the

*studio. On warm days, I'd sometimes put her chair right out-
side the door. She would sit silently, her legs out, her feet on
a stool, her eyes closed, her face turned away from the sun. In
Santa Fe, though, she was increasingly unwilling to venture
out. She would say, "I am not particularly keen about it,"
meaning sitting outside. She'd use that word, "I am not keen
about that."*

*She would sit in her room, with her feet propped on a
molded plastic chair, a white one brought from Abiquiu, with
a throw over her feet. I would help her put her feet up and
then, when she was ready to change position, or walk, would
help her again. It seemed that it was easier for her to lift her
legs up than lift them off the chair and lower them. She had a
movement she would make when about to get up from a sitting
position. She would incline forward slightly, her back very
straight. It was almost like bowing, a preliminary gesture
with her upper body that would help her with her balance.
Sometimes, when I would help her stand, she would extend her
arms like a child, as if to be pulled up by her hands instead
of steadied on an arm.*

*A trip down the several steps into the living room was dif-
ficult and she preferred to avoid it, although I often insisted
upon it so exercise would enliven her spirits. The walk out to
the back portal was similar: there were steps, and she tried
avoiding it. With her cane, slowly, we managed it, and she*

never slipped. In the late spring and early summer we spent some lovely times in the sun under the portal *but she would be annoyed by the sound the workers made in the yard and would quickly tire and want to go indoors.*

It was a very long spring, with long busy days; not a time to be thinking about death. There were still snowsqualls and one storm I remember. Of course, there are winds in New Mexico in the springtime. They are drawn from the north in the morning and in the afternoons there are sometimes winds from the southwest, violent winds which occur suddenly.

The long summer days would be relieved by Santa Fe's cool evenings, sometimes by rain, a respite after the heat of the desert sun. Often I would be staying late. We would sit with the courtyard door open, the door near the wicker couch, allowing a breeze, and with the new lawns and all the trees there was always the lush smell of greenery, a smell not always associated with high desert, with Santa Fe.

Although there was usually a registered nurse who spent the nights, I would often stay until eleven o'clock, working double shifts since morning, or having come at three o'clock.

Evenings were calmer in the house. We were usually alone in Georgia's room, and instead of the noise of the day, there were crickets and quiet, undefined night sounds, muffled city sounds. I wished her hearing were better so that she would not be so isolated from those soft summer noises. Somehow, there

Miss O'Keeffe

was a special sense of intimacy then, in those evenings. Perhaps it was just the contrast with the day. And I suppose it might have had something to do with the isolation, the separation from Abiquiu and Ghost Ranch, which provided a focus for us, unseen, a shared sense of not belonging there. Sometimes in the evenings she would even seem lighter, and more talkative, as if she had worn the day away and was ready for some fun. The evenings in Abiquiu had been dark, sleepy winter ones, whereas these in Santa Fe were light, the slow releasing into night of the long, vivid summer days.

Gradually, her demeanor was losing repose; it began to seem resigned, discouraged. Her posture while sitting was less erect, her responses less immediate and as if from a greater distance. Her shoulders slumped, her jaw slackened more as she dozed in her chair. She would want to move from the couch to her chair and back again more often, sometimes not remembering she had just moved, and she would be unable to get comfortable. Worse yet, she'd ask if she could take a nap when she had just awakened from one. Then she would be unable to agree that such was the case, challenging it or most often frowning and drawing her lower lip upwards and falling silent.

By midsummer she was very confused about a lot of things and resumed calling me by a variety of names: Chatterley, Candelaria, Catherine, Ida, or Cathay. Her memory was changing, her short-term memory as well as her long-term

memory. She often would not be able to remember whether she had eaten or not and sometimes would get very upset that "that girl in the kitchen won't let me have my food," right after she had eaten.

In July, late one night, she pointed to the lamp which was on and asked me to close the curtains so the sun would not shine in her eyes. She was distressed that she did not remember it was night or that she couldn't tell the difference. She was ready for bed and didn't speak much at all until she decided to use the bathroom and retire. No smiles that evening.

Her pattern was to move from the wicker couch to her chair, then perhaps ask to lie down on the bed. Constant attention was necessary when she was awake; it was necessary to be in the room while she slept also, because she might suddenly wake up and need to go to the bathroom. She was often abrupt and urgent when she awoke from a nap, intent upon not soiling her clothing. Thus, the constant presence of a nurse or companion was necessary at all times. She would often wake up with a pain in her leg and she would need a massage.

She didn't like to be in a wheelchair at all, but she knew it helped other people when they had to handle her. She told me one time she and Hamilton were someplace and he put her on a wheelchair and ran very fast with her. She laughed about that, having enjoyed the speed. When she went on an airplane she had to be in a wheelchair to avoid all the walking to and

from the plane. When she was with me, there wasn't the occasion to spend much time in one. About the only time I used the wheelchair was to take her to the other side of the house, to the guest bathroom where there was more room to wash her hair. Then, still sitting on the chair, Pita and I would lean her back and her head would be level with the sink.

She got so she hated to take a bath. Pita and I would bathe her together on Fridays. The nature of her baths changed completely in Santa Fe. In Abiquiu, she had loved them. Now they had become a problem and it took two people to handle her safely; she was feeble enough that it was dangerous for just one nurse to attempt to bathe her.

One of us would help steady her and the other would lift her in. Georgia was able to get her legs over the edge of the tub, but she lacked the strength she had had in Abiquiu and therefore she resisted bathing. "No, I will not have a bath today!" she'd say. I would try to kid her out of her contrariness saying, "Oh, c'mon Georgia, it's time. You've got to have a bath today; you haven't had one for a week!" Sometimes the only way we'd get her to agree was to tell her that Hamilton wanted her to have the bath that day.

With her hair it was the same thing. She didn't want it washed, she'd balk, and so sometimes we washed her hair without giving her a bath. Afterwards we'd dry it with a hair dryer so her head would not get cold and her hair, which

was whiter now, would stand out like an aura. Here was this frail woman with gorgeous hair literally shining like silver. It shone like that even on days when it wasn't washed, although it was much tighter to her head then and it had a tendency to get oily. Her hair should have been washed every few days so that it could have stayed full. After washing, each single hair seemed separate, it seemed lit from within and floating away from her head as if about to carry her off.

She had an angelic look coming out of the bath with her hair washed; it was an experience to see her, she looked so magnificent. Her face would always be rosy; she looked like a child, a baby who's been in the water and comes out shiny. She had always loved that aspect of bathing, the feeling of being quite warm and renewed, and she had always wanted the water very warm. She preferred to have the water lukewarm at first and insisted on feeling it with her hand before getting in; once she was in she had me turn on more of the hot. Pita and I laughed about, and ignored, the directive we had gotten to save Georgia's stray hairs, so that ringlets could be made for future collectors.

The confusion she felt between the Santa Fe house and Abiquiu was apparent in the middle of the night. When she'd get up to go to the bathroom she would often want to go in the direction she had been used to in Abiquiu. One night she

insisted on going in the wrong direction and I just gave in. She tried to sit down on the fireplace hearth, then realized her mistake and we finally got back to the bathroom. She was insistent upon not going in the right direction, and she called me a fool. She said, "You fool, the bathroom is that way."

I told her about it the next day, laughing. "Georgia, I have to tell you something funny. Last night you tried to go to the bathroom in the fireplace." She laughed and laughed and then said, "Well, you know, the person who tried to take me there was a fool!"

She began telling me by late July that she didn't want me reading to her much any more because she couldn't remember what had been read by the time we got to the next sentence or paragraph. I had been reading her a manuscript on Stieglitz, written by Sarah Greenough, that Hamilton wanted her to check for corrections. She wasn't interested in it at all. My reading of the manuscript only lasted a few minutes. She told me to stop. "I wonder why someone is telling me about that; I already know that." She wasn't able to make the connection that this was a manuscript someone had written and not something being communicated to her directly. We put the book down and never read it together again. Each time I offered, she refused.

Although her powers were waning, Georgia's youth and

earlier maturity seemed to be integrated throughout the accumulation of her years, all of the stages of her life intertwined, each no longer seen but part of a matrix which formed her being. That experience continually nourished and recreated this distinct woman. Visually, she was civilized, attending to simplicity. I saw in her a center balance, as in a fine dancer secure in the air, still and unmoving in a leap, youth emerging intermittently as a refining process, a clarifier—the dancer's knowing.

I used to look at her and see the young woman within, her eyes no longer looking out upon the world as they had when she was young, but whose mind remembered—the childhood memories of her brothers and sisters still fresh in her mind, or early morning visits with the interesting people in the shacks near her house, returning before being discovered by her father, who would "raise a rumpus" about that—memories coexisting with present-day events, present-day friends. Her youth would reveal itself in a sudden laugh, or the way she would show delight at something new; then I would remember that being old is more than it seems.

I remember looking out from my own middle age, seeing the world as if I were still young, and knew that she did too. That her wrinkles were a distraction, a camouflage, a screen for privacy, perhaps; I knew that her halting speech sounded different to her, inside, and if she could have seen well then,

Miss O'Keeffe

the image of her old face would have had a meaning very different to her from what it meant to us. Her slow gait revealed a tempo we do not yet know. At those times, I would not see an old woman: the whole of her life was present, obliterating notions of time.

Nineteen

At this point there was only one book O'Keeffe wanted to be read to from and that was Kandinsky's *Concerning the Spiritual in Art*. She could only take one or two sentences at a time, but then she would talk about it. As she said, she *knew* it, and would murmur "Oh yes," and her face would relax. She would be very quiet for some time and then want to hear another sentence.

One afternoon after her nap they were sitting—she in her customary pose in her white chair near the window overlooking the large yard, half-snoozing, and Christine on the wicker couch. Christine was reading *Vanity Fair*, which she found in the room and she happened to read a piece in which a fashion expert was quoted as saying that any well-bred woman knows how to walk across a room without her shoes making a sound; she added that such a woman "polished the bottoms of her shoes." Christine hooted. Georgia asked what that was all about

and she told her. O'Keeffe commented, "Some people waste too much time on a lot of unimportant things, don't you think?"

O'Keeffe often received letters from people she didn't know. Pita once gave Christine an assortment of cards and letters to read to her. She listened carefully to each one, attentive to the moment, as always.

O'Keeffe told Christine that she once loved to read poetry. Christine asked her if she wanted to be read poetry and she said that now she was this old it was hard for her to understand it the same way she used to understand it. The same applied to music. She didn't want to listen to music anymore. She claimed she couldn't hear all the tones in the music she knew so well. "It's a pain to hear it and know it isn't right, that I am not hearing it right."

In spite of this, and perhaps because that house called for magniloquent gestures, an arrangement was made with the Santa Fe Opera to borrow one of their grand pianos. The first one they brought was marred so it had to be replaced. They brought another one, quite a beautiful piano. There were a number of times when a string quartet from the Santa Fe Chamber Orchestra would come and play. Everyone would sit on chairs in the living room while the musicians played in the

dining room, which made a good stage since it was slightly raised. O'Keeffe enjoyed these particular mornings; she loved the music but would comment later that sometimes it hurt her ears.

About the only person who made casual visits was a woman with whom O'Keeffe said she had traveled throughout Africa years before. She came once a week for a while that summer, bringing fresh fruits and vegetables from the farmer's market in Santa Fe. She would visit for a few minutes, and O'Keeffe told Christine once that her husband owned gold mines and had done very well.

She brought clothes for O'Keeffe—bright, cheerful summer dresses. O'Keeffe would want to try them on after her friend had left. Christine remembers one dress with pink flowers, or perhaps it was pink with flowers of yet other colors, short sleeves and a full skirt. When O'Keeffe had it on she asked Christine's opinion. She had helped her struggle into it and remembers how odd it looked on her, an unpredictable dress for Georgia O'Keeffe. There she was, with her arms out, a look on her face like that of a little girl who wants to go to a fancy party. Since she really could not see the dress, Christine described it to her, the color, the pattern, how it fit, careful not to reveal her own opinion. But it was

no use; she couldn't fool her. O'Keeffe's face fell. She said, "You mean, it's not me?"

To Christine, there was something very touching about those dresses, that O'Keeffe's friend brought them in the first place and that O'Keeffe accepted them so eagerly. Everyone knew she had ample clothing, carefully chosen, so her friend's desire to share with her, to give to her in some way, to clothe and feed her, involved something besides dresses, something about an old friendship.

O'Keeffe discussed those visits; she said it was odd not to have friends to see—that to be the one who lives so long leaves you without friends. She was lonely for old friends, she confessed to Christine. Referring to another friend, she would light up when she'd think of Anita Pollitzer: "We were friends forever," she said, and added that knowing she was dead "makes you feel a little lonely." The friend who brought her fruit and clothes helped her forget her loneliness.

One day a week she would don a special apron and she would sit at the little table and roll coils of clay. Mino Lopez, the kind, burly son of Candelaria and brother to Pita, would then make pottery; he would form pots for her. She would spend perhaps an hour or so rolling coils. As the work progressed, she would feel the pots

lovingly and comment on them, directing any changes. In the beginning, it had been Hamilton who had taught her the rudiments of making pottery, and it was he who fired these present pots for her. She looked forward to those days with Mino.

Christine still drew at the Santa Fe house when O'Keeffe was asleep. Hamilton had provided Christine with a remarkably sturdy card table which he said O'Keeffe and Leo Stein, Gertrude's brother, had carted all over Europe once upon a time. In Abiquiu there had been long stretches of the day or the night alone or with O'Keeffe in the studio when all she needed was to be near her ward; she wasn't needed for specific care. And O'Keeffe had told her how she liked the idea that someone was drawing near her, in her studio, her room. "Imagine that. . . ."

Christine sought to bring O'Keeffe into it when she was around. She brought charcoal and gave Georgia paper to draw on. She liked the idea and chuckled once, "Imagine drawing when you can't see the paper very well." Christine had thought that perhaps the process of using her hands to make a drawing would renew those feelings in O'Keeffe of making art, engage her inner resources, and possibly give her a certain amount of pleasure.

Miss O'Keeffe

Now, with everyone in the same house, the Hamilton children came into O'Keeffe's bedroom occasionally. The older boy liked to play with the electric bed, making it go up and down and take odd shapes, pushing the button that ran the motor over and over. The younger boy would go to O'Keeffe, climbing noisily up next to her on the couch, or standing in front of her, patting her knees as little children will do. O'Keeffe seemed delighted as long as the visits were brief and as long as she was not alone, at the mercy of unpredictable, energetic little boys.

There were flowers often in the Santa Fe house, flowers that came from a local florist. Some would be put in O'Keeffe's room. When Christine first started working for her in Abiquiu, she would place a little bud on her lunch or dinner tray to make it more festive, but O'Keeffe didn't seem to care about it much. It was some time before Christine realized that she simply could not see well enough to enjoy it.

There was a new way of functioning now that O'Keeffe was in Santa Fe. The dynamics had changed. It was necessary to change their routines, since there were others in the house. There was more cooking involved, too, and more time away from O'Keeffe.

Miss O'Keeffe

During that spring and summer, dinner would usually be brought from a restaurant in Santa Fe. The kitchen was remodeled during that period, and although it was usable most of the time (Christine always cooked the noon meal there) she was seldom asked to cook dinner. O'Keeffe would sit at her card table in her room, the drawing table, and dinner would usually be salmon or lamb chops, soups, favorites of hers.

On Easter, dinner was a production, and it was eaten early in the day. Christine stuffed a leg of lamb full of garlic cloves. There were boiled onions and vegetables. O'Keeffe, the Hamiltons and Christine ate in the large, nearly empty living room on the glass and mirror table there, the table that would eventually be in the dining room. It was some of O'Keeffe's favorite food and she ate heartily, responding to the sense of holiday.

There was an abundance of fresh produce at all times, something that had not been the case in Abiquiu. The freezer was always stocked with meat but Christine was instructed by Anna Marie, who was very health conscious, to ease O'Keeffe into a regime where the principles of "food combining" were applied. The plan was to slowly change the balance from so many dairy and meat products to more complex carbohydrates, more

fruits and vegetables in the right combinations. It was important to watch that she didn't eat melon, for instance, along with other fruit.

There was a good deal of waste in the kitchen. Anything that wasn't absolutely perfect was thrown into the garbage. The compost pile was the gainer. Because there was so much fresh produce, so many flower cuttings, and probably because she was an artist, Christine was intrigued by the look of the compost bucket in the kitchen. There was a continually changing visual feast, colorful and vivid. It would eventually be taken out to the pit that had been dug behind one of the guest houses.

But food wasn't always the harbinger of happiness at the Santa Fe house. That summer a friend of O'Keeffe was having lunch with them and meat was going to be part of the meal. Hamilton told Christine to have O'Keeffe wear her partial dental plate, a couple of molars which she left out most of the time. When Christine got it for her, as they were washing up prior to the event, she said, "I won't be wearing that today."

"But Georgia," Christine objected, "we're having meat for lunch. It will help you chew."

"I told you," she said emphatically, "I won't be wearing that today."

Miss O'Keeffe

The guest arrived, and everyone was seated around the dining room table. Candelaria had cooked the meal, having come in from Abiquiu for the event. Georgia was at the head of the table, and Christine was to her left. Hamilton sat to Georgia's right, directly across from Christine.

As they were eating, with O'Keeffe having no trouble, Hamilton said to her, "Georgia, did you put your teeth in?"

O'Keeffe looked up at him, silent. He looked at Christine.

"She decided against it," Christine said.

"Go get them," Hamilton ordered.

She looked at O'Keeffe, then got up from the table. When she returned with the plate, Hamilton took it from her and put it in O'Keeffe's mouth himself. O'Keeffe said nothing, she continued eating silently, deliberately. Suddenly she announced she was finished and asked to be taken to her room. As Christine was helping her prepare for a nap, O'Keeffe asked to go into the bathroom.

"Is the door shut?" she asked, once inside. "Is anyone in here with us?"

Christine assured her that they had privacy.

"Can you imagine that? I've never been so angry.

Have you ever seen anything so rude? Why, I have a right to leave my teeth out if I want to," she said.

The days differed from one another more in Santa Fe than they had in Abiquiu. More was going on, and there were others around. Even though kitchen and bedroom were under the same roof now, they were separated by a fair distance and so Christine couldn't hear O'Keeffe when she was cooking and therefore had to do a lot of running back and forth. The entire time she took care of O'Keeffe, Christine was never comfortable with being in a different room, out of earshot. O'Keeffe still had her whistle but she didn't use it to the extent she had in Abiquiu. O'Keeffe was unsure of the place; it was as if the old way of doing things might not work, which was, of course, true. Getting back to secure routines took Christine a long time because there was the new need to respond to the rest of the household.

Sometimes, when she got to work at seven in the morning, the night nurse might already have fixed breakfast. O'Keeffe would be sitting on the couch, having eaten or in the process of doing so. She might have been dressed also, depending on how early she had awakened, but the old, firm getting up at six o'clock was no longer the rule. That was one of the signals to Christine that something enduring had changed within

Miss O'Keeffe

O'Keeffe, for she was letting go of something important to her. Christine spent the night at the Santa Fe house a couple of times and noticed that O'Keeffe awoke during the night just as often as before, maybe even more, but that it seemed to tire her out more. In Abiquiu, even when she had been restless, she was determined to get up at six every single day. Here, it was more complicated. It was clear that she was not living her own life any more.

Often when Christine arrived O'Keeffe would not have had breakfast and she would prepare it for her. This consisted, in those days, of eggs with fresh chopped vegetables on them, a small piece of toast and some fresh juice. There was a juicer in the house, one that wouldn't make much juice at a time and which was hard to clean but which allowed for all kinds of fruits or vegetables to be used. Sometimes O'Keeffe would have oatmeal or some other cereal although there weren't as many choices in the Santa Fe house as there had been in Abiquiu. Christine tried to encourage O'Keeffe to eat fresh fruits in the morning although she was accustomed to something a little more hearty. Adding the vegetables to the eggs was the best Christine could do in the attempt to gradually ease her toward better combinations.

Miss O'Keeffe

The noon meal continued to be a major event, one way or another. Sometimes others would eat with her, others in the household; as often as not it would be just she and Christine. They would usually sit in the dining room at the glass table, with Christine to her left. The dining room looked out onto the courtyard and Christine liked facing that window. She watched the workers lay down the sod, a job that had to be done twice since the first time the ground underneath wasn't leveled properly. Occasionally, there would be a bang or a thump against the window, and it would be a bird ignorant of windows.

As mentioned, that room was pretty bare at first but, later, one of the "Black Place" paintings was placed on one of the walls. The famous Ansel Adams photograph of the moon over Hernandez hung in the kitchen and there was an early watercolor of O'Keeffe's in the office. A "Jack-in-the-Pulpit" hung on the far wall of O'Keeffe's bedroom. Christine appreciated those paintings more than the ones that had hung in the Abiquiu studio. She felt fortunate to have spent so much time near them, seeing them. Sometimes, when going through the dining room on the way to the kitchen, she would stop for a minute or two and look at the "Black Place" painting. If she had time to herself she would sit

in front of it and sometimes felt she had walked into that black place. Later, upon seeing another one from that same series at the Metropolitan Museum in New York, Christine was immediately transported back to those days when O'Keeffe had sat in that dining room very erect, eating, and the two of them had faced the painting.

O'Keeffe needed help eating now—another sign that she was letting go, realistic about change. The cooking at noon usually took quite a while, for a lot was going on in the kitchen, with the carpenters tearing out the old and installing contemporary fixtures and what not. Members of the household would be going in and out of the kitchen bent upon their own pursuits. It was Christine's new responsibility to cook for Hamilton who would sit at the table for lunch perhaps half the time on weekdays. Weekends were much quieter, for the family was often gone and there were no workers around.

O'Keeffe had been taken off salt and it took Christine a while to learn to cook without it. She hadn't been aware prior to that how much she had depended on ingredients that had salt in them. The noon meals consisted most often of soups and salads, always with freshly made salad dressing. A lot of herbs and garlic were used, and lovage was often brought in from Abi-

quiu. Sometimes a fish vendor would arrive in Santa Fe and there would be fresh shrimp on the table.

When it was just the two of them, and if O'Keeffe wasn't up to the formality of the dining room, she would eat in her room, either at the small table or just sitting on the couch. Christine would sit next to her and help her. That summer they tried eating outside a few times, on the *portal,* but the noise and the activity were not conducive to a peaceful meal and they would decide against it the next time they were tempted to try it.

The sense of time was different in Santa Fe. With more interruptions all week long there was much less time for the languid and serene life Christine and O'Keeffe had shared in Abiquiu. Then, too, O'Keeffe's failing health, her diminishing spirit, made her less comfortable. There was, somehow, a prevailing sense of waiting for something, as if these days in Santa Fe were a mere interlude and things would go back to being as they had been, perhaps back home.

It was a long spring. O'Keeffe never lost her love for Ghost Ranch. She yearned for it and she would often complain to Christine that she would probably never see it again. She'd speak longingly of the cliffs there, and she wanted them back in her life.

She kept asking to be taken back; she wanted

Miss O'Keeffe

Christine to take her there for a few weeks, a most unlikely thing given her condition. But another nurse thought she and Christine could split the time there and do it. One particular afternoon they got talking about it. They were sitting in front of the window in the bedroom and the sun was pouring in. Spring noises outside inspired confidence in such an adventure and it seemed possible, within reach. O'Keeffe started describing certain things about Ghost Ranch to Christine, that "most beautiful back yard in the world."

O'Keeffe described the area around the house and how she finally had to wall it in when she got her chows because of the rattlers. Christine's enthusiasm was immediately dampened at the thought of snakes, of being alone with O'Keeffe in that world and having to contend with slithery beings. She told O'Keeffe she really didn't have much experience in dealing with snakes.

O'Keeffe smiled and leaned over toward Christine, as she always did, sort of sideways. She said, "Oh, my dear, you don't have to worry about that. We'll take care of them together. You just take a stick or a shovel and take care of them; you kill them and you just get them out of the house."

As far as Christine knew, O'Keeffe never got to go back to Ghost Ranch. O'Keeffe was taken to Abiquiu

once when a friend came from New York to visit for a few days, but that was the extent of her outings that summer.

Once, when O'Keeffe was talking about her world travels, Christine asked what her favorite place was besides Ghost Ranch. O'Keeffe paused and with a wistful look on her face examined her memory. The timing was splendid; she had paused, thinking, while Christine anticipated hearing of some exotic African village. Then she said, "Amarillo, Texas!" as if it had been a sudden great discovery. She talked about the trees there, how green they had been when she had lived there so many decades before. And how they had turned yellow. "There were beautiful yellow trees there, the most beautiful yellow trees in the world."

Twenty

That summer I got sick with an intestinal disorder and was away for almost two weeks. Discussing it with Hamilton later, he said it was probably his fault. I asked what he meant and he looked at me, very startled, as if he hadn't meant to say it, and said, "Nothing," turned around, and walked out of the room. I began to suspect that maybe it was the water because the plumbers were doing a lot of digging, the pipes were exposed, and I hadn't been drinking or eating anything different from what I usually had. In the house they drank bottled water, but the help was supposed to drink the tap water.

Perhaps there was a connection to the water problem in the fact that the house developed a particularly bad fly problem. At one time there were flies everywhere. It seemed as if they were breeding underneath some planks in the old part of the kitchen. The kitchen was full of flies at one point and they were breeding just as fast as we would kill them.

I was asked to go around the house with a fly swatter and

kill flies throughout the house. I had a fly swatter in Geor-
gia's room because they bothered her but it was unrealistic to
go around the entire house doing the same. It took me away at
the expense of Georgia's care. She would be left alone at such
times. I would often return to find her pleading for someone to
help her.

My interest was in Georgia; that was the only reason I was
not in my studio. Yet, as time went on, I was called out of
the room more than before, and more than was comfortable for
Georgia. It happened so subtly that I wasn't aware for a while
that it was even going on.

Someone was supposed to be with her, but usually when I'd
return, I would find her alone. That became a big problem
because not ten minutes went by without Georgia needing some-
thing. She would want to take a few steps to another chair,
she would ask for a glass of water, she would need to go to
the bathroom. Often I came back to her room after having been
occupied with a chore in the kitchen to find her calling for me,
"Christine! Where are you? Hurry!"

When I would tell her I was given chores to do she'd say
it was not what I was there to do. When I'd tell her it was
Anna Marie who was requiring my time, she would be very
annoyed and grow silent. At that point she was having a lot
of trouble with her bladder and needed constant attention, so
it was nerve-wracking. She was quite used to having the help

she wanted when she wanted it and while she was gracious about it, extremely grateful and loving about it, she did get impatient when the help wasn't there when needed. It was summer, there was a great deal of tension in the house, and I was unhappy about being called away from Georgia.

About that time, Dr. Friess, an old friend of Georgia's from back East, came to visit her. She had been Georgia's doctor in New York and was an elderly, white-haired woman with a round face and grandmotherly ways. She was very gracious, very gentle and refined, loving to Georgia and very interested in her. She came for a few days of vacation, but gave her a physical. She seemed worried about what she found in terms of health and environment. We had a conversation in the bathroom—that was the place for real privacy—about what was going on. She was upset about the feeling in the house, with all the tension and activity, indoors and out. "What's going on here?" she asked. We stood there and talked for a few minutes.

I trusted Dr. Friess and felt she had some influence. Because she was Georgia's good friend, I felt free to talk with her. My allegiance and concern were for Miss O'Keeffe's welfare.

She and Georgia and Hamilton went to Abiquiu and spent the night there, coming back the next afternoon. Dr. Friess had asked me if it was all right to bring up her concern with Hamilton. I told her yes, at her discretion.

Miss O'Keeffe

When they were back, Hamilton asked if I had said anything to Dr. Friess. I told him we had had a conversation. He said that Dr. Friess had grilled him about a few things.

He was unloading the car and we ended up in Georgia's bedroom with her belongings. He had parked in back of the house which was unusual. Dr. Friess had gone in the house and Georgia was already in her room. I had gone out to help with the suitcases. He said he expected loyalty from his employees, that it wasn't up to me to be telling people what was going on in the house or anything about their private lives. This seemed strange to me because he had repeatedly said I worked for Georgia, not for him. I told him it seemed to me appropriate to talk to Dr. Friess about it because she wanted to know and it was Miss O'Keeffe's welfare that was the important thing to her.

That was about the time when things started to change for me there. I left probably seven or eight weeks afterwards.

The day before I quit, in late August, I had arranged to trade several hours with another nurse and go down to the Albuquerque airport to pick up a friend who was coming into town. I had three hours in which to do it. It was lunch time and I was cooking prior to departing. Hamilton had asked to eat and then had changed his mind, after the meal was cooked. I had made a squash dish and asked Hamilton if I could have

it inasmuch as he wasn't going to eat it. He said yes so I put it in a paper cup with a spoon and began walking out. At that point he made the comment, "Always eating, always eating!" And then he grabbed my belly, squeezed it twice, and added mockingly, "Back to the gym!"

I was stunned. As he walked away all I could do was turn and go to Georgia's bedroom, where I threw the spoon across the room. The nurse, who was relieving me could only say, "Oh, he didn't mean it . . . it was just affection . . ." But I was so upset that I cried most of the way to Albuquerque.

That night, when I came back to work, Hamilton and I had the beginning of a confrontation that continued the next morning and led to my departure. I had offered many times to cook dinner so they wouldn't have to bring food in. Occasionally they took me up on my offer and would notify me in the afternoon that I would be cooking that evening. That night, however, no one said a word about dinner. Hamilton drove off and didn't come back. Normally, he would return with food from a local Santa Fe restaurant, food for the entire household.

Georgia wanted to wait and not have me fix something because she said he would be angry if he showed up and we had eaten. Time went by. I tried to read to Georgia but to no avail, so I told her stories; we ended up talking about all kinds of things.

Miss O'Keeffe

A number of times I told her I would go to the kitchen and fix something for her but Georgia was very insistent upon waiting for Hamilton to bring the food.

Suddenly he was there, in the darkness, leaning against a post on the portal, just outside her door. I asked him, "Am I to assume that you are not bringing dinner tonight?" I wanted to make sure he hadn't left it in the kitchen, but I was actually angry at him and was not being very polite.

His answer was, "I think you could manage to cook dinner once, don't you think?"

I went to the kitchen and fixed a dinner quickly. I didn't see him any more that night.

Things had reached a crisis, and I decided it was best, under the circumstances, to speak with him in the morning. I was back at work at seven A.M. and went to the kitchen to fix Georgia her breakfast, nervous about confronting Hamilton. She was already sitting on her couch. Hamilton came into the kitchen and said that we had some things to talk about. He said that he didn't appreciate my attitude about not being willing to cook for Georgia. I said, referring to the previous night, that I had heard him drive off following the usual routine and that, instead, he hadn't come back and there had been no dinner. I pointed out that Georgia had been very upset about it and had insisted upon waiting.

He started wandering off into other things, talked about

the burden that he had had and how when a lawyer from New York had come into town and had seen him have to go get dinner every night, he had said, "For God's sake, you've got all these employees. Why don't you have someone cook dinner?" Hamilton said the lawyer thought I ought to be able to cook dinner. "Why couldn't you cook dinner?"

I was dumbfounded. I cooked dinner often enough, when I was asked to. At other times when I wasn't asked but it looked obvious there wasn't anyone around, I cooked dinner. It seemed unbelievable to be discussing this.

Finally he said, "What I think is that you are working too many hours a day and I am not going to let anybody have that many hours anymore." He said, "You are strung out. You can't do this kind of job."

I brought out the fact that for ten years I had often worked sixteen hours a day and that this was a much easier job than running a business. "It isn't that at all," I said. "It's just that it is difficult to communicate with you," the irony being that here we were having the only decent communication in our history. As the conversation went on I realized things weren't going to improve, and I said, "I'll give you notice and wait until you can find a replacement for me. I'll work for two weeks, or until you get someone appropriate." Hamilton seemed relieved, he liked that idea.

There was a telephone call at that point and he left the

room. *I went to check on Georgia and then went back into the kitchen. When I returned I had gotten up enough courage to say something about the incident the day before. I was quite upset and only managed to say, "And I have to tell you this . . ." when my voice broke. It was through tears that I went on, "I was very upset about the way you grabbed me yesterday. I was humiliated and insulted . . ."*

At that point he astonished me. With an absolutely straight face he denied having touched me.

I took off my apron and told him I was quitting immediately. He was furious. "Oh, you're just going to walk off, eh? You're just going to leave Miss O'Keeffe? Who's going to take care of her? You're going to abandon her?"

One of the plumbers happened to walk into the house just then. I told Hamilton, "I am quitting because you grabbed my belly and made fun of me and humiliated me!"

Hamilton denied it again. I looked over at the plumber and he looked over at Hamilton in such a way it was obvious he understood what was going on.

I went to Georgia's bedroom while Hamilton was still shouting at me. I was in tears and shouting back. He followed me and told me, "You are going to have to explain to her why you are going to abandon her!" He then turned to her, "Georgia, she's leaving you, Christine is leaving you. She doesn't want to take care of you anymore. She doesn't care about you!"

Miss O'Keeffe

I sat down and told her, "Georgia, I am leaving because Juan and I can't get along; we've talked about it before, you know. We have had many discussions about it."

Hamilton continued diminishing the episode. "I tickled her; you know how I tickle you and tease you! That's what I did to her and she thinks I'm some ogre."

At that point I got up and started gathering my books. Georgia was looking from one to the other nervously and laughing because there was so much commotion. She said something to me that I didn't hear. There was no way she could get a word in edgewise.

I gave Georgia a big hug and told her I loved her and was so sorry to go. She giggled out of nervousness and said, "Yes, I understand," and I told her I would come back and visit with her if I were allowed to return. Hamilton started laughing. "Do you think I'd let you back in the house after this?" He said, "You'll never see her again!"

Twenty-one

Early in August, O'Keeffe's will was changed, much in favor of Hamilton. It was a particularly chaotic week in the household; there was a lot of activity preparing the main house and guest house for visitors. O'Keeffe's lawyer from New York arrived on Tuesday, and people had been in and out for days. Her local doctor had unexpectedly interrupted lunch the day before to take a sample of O'Keeffe's blood. The house was full of flowers, many more than usual, brought by Anna Marie from a local florist.

Hamilton seemed agitated. All week, his directives had seemed more brusque than usual, and he appeared excited by the arrival of the guests. Before he left to pick up the lawyer from the airport, he came in to tell O'Keeffe and she said, "Tell him about our plan, Juan." "Oh yes, Georgia . . ." he replied, finishing the sentence inaudibly.

Miss O'Keeffe

When Christine heard O'Keeffe say that, she immediately recalled a conversation she and O'Keeffe had the month before. Occasionally, Hamilton would visit O'Keeffe in her room in the afternoons or early evenings for perhaps a few minutes. At such times he would ask the nurse to take a break.

On this particular occasion, he stayed in the room for over half an hour. When Christine returned, O'Keeffe was very agitated and told her that Hamilton said that he and she had to get married.

Christine always had a drawing book with her and, as O'Keeffe began to relate what had taken place between her and Hamilton, Christine realized she wanted to write down what she was hearing, she was so stunned.

They were sitting together on the couch; O'Keeffe spoke very slowly, pausing to think between words. This made it easier for Christine to write down the conversation accurately. The date was July 10, 1984.

O'K: *Do you think of this as my house?*
CTP: *Well, of course.*
O'K: *Or does it seem like Juan's?*
CTP: *Well, there are some of your things around it.*

Miss O'Keeffe

O'K: *Well, I just don't have any feeling of possession. The house in Abiquiu feels like my house. When we went up there {this was shortly after she had gone to Abiquiu with Juan and Dr. Friess} it didn't feel like my house anymore. Well, you know, it seems like it's Juan's house, and if I have that feeling maybe I should just give it to him. Are you sure it feels like my house?*

CTP: *Well, his family does live here. Maybe that's why it doesn't feel like it's your house. That would be a very nice thing to do, to give a house to someone.*

O'K: *But it would have to be made legal. If that girl— what's her name, Mary Eva {Anna Marie Hamilton}— would quit, then Juan and I could get married and be done with it. Does that seem a funny thing to you?*

CTP: *Funny?*

O'K: *Well, if I give him the house and we aren't married there are taxes, he said. The government wanted to have the house in Abiquiu—there've been many plans and I don't know what will happen.*

CTP: *I've always thought the Abiquiu house would be a great art school—a small one.*

O'K: *Oh yes.*

CTP: *This house used to be a school.*

O'K: *Yes, Juan . . . do you think it's a funny idea?*

CTP: *What's a funny idea?*

Miss O'Keeffe

O'K: *This idea of getting married. You see, the people have always gossiped about us, and they've never known and if we get married, I suppose that will start it up again. And it would be a legal way. And they've already gossiped. And then people will tell us: we told you so. Because he takes care of my affairs . . . he knows more about my affairs than I do. And I wonder if he talks to his friends as I've talked to you?*

{Pause . . . }

But I'm afraid that maybe that sort of thing will change if he thinks it's a duty.

CTP: *Do you mean his taking care of you?*

O'K: *It's not just care—it's a kind of feeling. You take a great big risk {laughs}. You see, the house would then belong to the two of us, and we'd have to get married to prove it, and that seems very funny because we've been talked about anyway.*

{Pause . . . }

When it comes to taxes, that's what is. And if he's a partial owner, only he pays taxes. I don't think the government looks into and {sic} wherefore of such things but I think they should. He has talked to Anna Marie, and it's all right with her to stop being married.

CTP: *Would they keep living together?*

O'K: *Well, I don't think there's much living together going on. Well, it seems funny for him to go around strangers saying, "This is my wife."*

Miss O'Keeffe

CTP: *You mean you?*

O'K: *Yes {laughs}. I'm rather indifferent about it. I think I'm more indifferent than a lot of people would be. And it would be strange to go around saying he's my husband {laughs} . . . I'm afraid that he might have less feeling that way than he does now.*

CTP: *Well, that happens, Miss O'Keeffe.*

O'K: *It would take awhile to get people adjusted to it. See, Mary Eva, or whatever her name is, seems to have no feeling about giving him up. And here he is a desirable young man {laughs}. Oh dear, it is funny.*

CTP: *I wonder what she will do—she doesn't have a job . . .*

O'K: *Well, she's just to go on the way it is. I doubt that that's what's giving her a backache. It may be, it just occurs to me.*

CTP: *It seems like an interesting plan.*

O'K: *It seems like an interesting plan? Well, years ago occasionally, he would say, "Let's go up to Tierra Amarilla to get married," and I laughed at it. It wasn't in my plan at all.*

CTP: *When did he start talking about it again?*

O'K: *Well, when this became a tax situation.*

CTP: *Well, can I come?*

O'K: *Well, of course!*

CTP: *I'll help you dress.*

Miss O'Keeffe

O'K: *Well, I can dress in that pink dress. I can wear a white dress. We don't have to dress up and do anything special. Well, I've already given him the Ghost Ranch house, but he says I haven't done anything to prove it so I've been called upon to sign something proving it. That's my back yard and then around it is my front yard.*

Some people will say what a terrible thing this is we are doing. The people will gossip about us. They already have, haven't they?

CTP: *Yes, but one mustn't live life worried about what people say about you, you know that.*

O'K: *Well, that's a nice broad way of looking. I just don't know if he won't feel a little funny attached to me in that way. And if we're going to do anything about it we have to do it soon.*

CTP: *Tomorrow?*

O'K: *{Laughs} Well, the sooner the better. And here that— what's her name—Anna Marie just gets ailing—as if it bothers her that much. You see, it makes a fine line of gossip. Well, you've been to the kitchen. You've seen what she's like.*

CTP: *She seems very tired.*

O'K: *Tired? Anna Marie? Well, I don't think this business is what's making her tired.*

{Pause . . .}

Well, here we have all of this house and all that goes with it and the things that he intends to put in it. I doubt he'll change his plan much about the house.

CTP: *What plan?*

O'K: *Oh well, a lot of things he intends to do to it. And it'll take quite a little money to do them.*

CTP: *Like what?*

O'K: *Well, like making a glass across the courtyard. Making it daylight. Now who else would do it? Well he has a lot of ideas about the house that way.*

CTP: *And it'll be easier to do those things if you get married?*

O'K: *Uh huh. We've already been taking this walk down the side of the house and back the other side up. It may be the people who work here who make words about it. I never talked to Dr. Friess about it. I should have talked to her about it . . .*

CTP: *Why?*

O'K: *Oh, just because she is a wise person.*

CTP: *Well, you're pretty wise yourself.*

O'K: *Well, I'm not too stupid, I don't mind saying that about myself.*

{Pause . . . }

One of the principal things is the feeling he has now is very

special. And it could change. And I suppose I'm just going to do it. And I hope that's not what's giving the backache to that other girl. There'll be something I haven't even thought of.

CTP: *What?*

O'K: *I don't* know *but I know there'll be something. I don't know what'll be done with all of that machinery up at the ranch. I suppose he'll put it in one of the buildings here. There is a lot of machinery of one kind and another.*

CTP: *Do you want to talk to Dr. Friess about it?*

O'K: *Well, I could telephone if I could get my ear {her hearing aid} so it works. I guess that's one of the better things to do, isn't it?*

CTP: *Well, why don't you get Juan to call her tomorrow? {Very long pause . . . }*

O'K: *And you see the way we live is he has the upstairs and I haven't gone up because it's so hard, but he just races up and lies on his bed to rest.*

And if he should die and leave all this to be divided among his family, that's another item I just thought of.

CTP: *And maybe you. . . .*

O'K: *Well, I would only have half. Which I don't especially mind, but it's a fact. That light up there is very bright. I never thought of her getting her backache because of this idea which he has undoubtedly told her about. And you know,*

it's halfway done if you start talking to one person or another about it.

{I got up to close the window and door.}

O'K: *Did you lock it? That's the door he will use to come in if he has forgotten his key, which he probably has. Candelaria, she has hurt her foot?*

CTP: *Yes.*

O'K: *So she can't cook?*

CTP: *No.*

O'K: *Well, that's too bad. It never occurs to me that I own this big house. Don't you think it's a little funny?*

CTP: *Why?*

O'K: *{Laughs} Well, it's a very big house and I always think of it as his house.*

CTP: *Why?*

O'K: *Well, he has all the say about everything. Everybody asks him about what they should do.*

CTP: *Even you?*

O'K: *Well I am sort of funny that I can't walk around alone and I have to have someone with me.*

I go through the gate and I stand on the other side until the person on the other side closes it and has it settled and goes to the house {this was a routine in Abiquiu}. Now, I haven't gotten up a habit here like that at this house.

Miss O'Keeffe

CTP: *Maybe when you do, it will seem more like your house . . . when you do more living in the other rooms.*

O'K: *Yes, they object to the arrangement of the kitchen and stove and all of that.*

CTP: *Yes they do.*

O'K: *And if that little house of his on the hill {in Barranca} I wonder if that's half mine?*

CTP: *If you get married?*

O'K: *Yes. I don't care if it is or not. There's what you think and wish and there's also the legal end of it. Now if I give up the house and half of it is his and half of it is mine that makes a difference. But I don't have any feeling of ownership. And I've talked to you forward and backward, haven't I?*

CTP: *It's O.K. It's been interesting. Does the idea of getting married make you happy?*

O'K: *{Laughs} It makes me puzzled.*

CTP: *Why puzzled?*

O'K: *Well, it is a kind of a puzzle when you've had a husband for twenty years to go to him in the winters and stay in Abiquiu in the spring and summers. You establish something. I'd been out here summertime and always gone back for the fall and winters, and he was a very special person.*

CTP: *Stieglitz?*

O'K: *Yes.*

CTP: *So that makes you puzzled?*

Miss O'Keeffe

O'K: *Well, it is puzzling.*

CTP: *Because of the memory of Stieglitz?*

O'K: *Oh no, that doesn't bother me.*

{Long pause . . . }

But I think if he would die I would have half right to everything he has, wouldn't I?

CTP: *I think so. It's complicated though.*

O'K: *And he's always so afraid I will die and leave him. He said, "What am I going to do if you're not around?" I wonder if his wife has to be legally disattached from him.*

CTP: *Well, I think so. . . .*

O'K: *I can't feel very gay about that kind of a marriage. It just doesn't feel very gay.*

CTP: *Is Juan gay about it?*

O'K: *Well, I think he's more interested in it than I am because he's giving up his rights.*

CTP: *What rights?*

O'K: *That's what I was just thinking. Well, he has a right with the people on the place. I don't pretend to have any rights with them. His opinion goes. And I think it will still go. There's evidently everybody who does things on the place . . . dilapidated . . . {The rest was lost, couldn't hear}.*

I wonder if he'll come back tonight. Well, my seat is getting tired. I just noticed.

{Got ready for bed}.

Miss O'Keeffe

The things I told you were funny, weren't they? Well, we didn't get the hair combed, but that we just can't help. You know, I think if I could rub it {Anna Marie's back is what I believed she meant}, I could do it a lot of good.
{Went to bed}.

Roxana Robinson, in her book *Georgia O'Keeffe: A Life*, in discussing the possibly undue influence brought to bear on O'Keeffe in her last years to change her will, tells how attorney David Cunningham, retained by the state of New Mexico to look into the possibility of having the state accept Hamilton's offer to give the Museum of New Mexico $1.5 million worth of art work from the O'Keeffe estate in lieu of paying taxes, came upon "the transcript of an exchange between O'Keeffe and a nurse." She calls the report of this exchange, within the context of the full report prepared for Cunningham by a former FBI agent, "an electrifying passage, which altered irrevocably the public perception of the Hamilton-O'Keeffe relationship."

O'Keeffe told Christine after the conversation she wrote down that when she wanted to discuss the proposed marriage with Dr. Friess by calling her long distance, Hamilton didn't think it was a good idea. She

also speculated about what was happening with Hamilton's marriage to Anna Marie.

She seemed to be getting more and more distant, and yearning for the Abiquiu house and for Ghost Ranch. She was very wistful about those places many times. She used to say, "I want to go to Ghost Ranch. Will you take me to Ghost Ranch?" and she made the statement once, "I'll probably never see Ghost Ranch again."

On that Wednesday morning in August, O'Keeffe, possibly in reaction to the increased restlessness in the house, slept considerably later than usual. Upon awakening, she insisted on a few more minutes before rising. Hamilton came into the room suddenly and wanted O'Keeffe ready on the spot. They had important business to take care of.

O'Keeffe sat on the couch barely eating a piece of toast. Christine reminded her that her New York lawyer was coming, as he had the previous afternoon. She murmured, "Oh yes. I suppose I should wear the white kimono today."

While O'Keeffe finished her toast, Christine went to get her clothes, wishing this once that her clothes were not kept so far away from her room. As requested, she

chose the long white kimono with its full, billowing sleeves. She then bathed and dressed O'Keeffe in record time, both of them agitated by then, fumbling everything, trying to make certain she was ready quickly, making sure her braid looked particularly fine. She took the lace handkerchief and held it.

"You'd think they could just wait until we were ready," O'Keeffe said, and then became silent.

The two of them sat together on the couch, finally ready. O'Keeffe took hold of Christine's hand for a few minutes. They waited all morning. Christine searched for Hamilton several times; she was finally told by Pita that he had left—that he had driven the lawyer out to his Tesuque studio to show him some of his sculptures.

When they returned, everyone had lunch in the dining room. There was no apology for having kept O'Keeffe waiting, but during lunch Hamilton laughed and said, "We should go out dancing tonight and celebrate, eh Georgia?"

She took a short nap. Her Santa Fe lawyer had arrived and Hamilton and the two lawyers went to the living room to talk. O'Keeffe was restless, so Christine stayed nearby. She was enjoying the breeze coming in from the grassed courtyard, but eventually closed that door as well as the one leading into the dining room to

muffle the noise, hoping O'Keeffe could get some rest.

Before long, O'Keeffe was up and Christine was brushing her hair, braiding it again, washing her face with a cloth. "Georgia, this place is hopping today, isn't it?" Christine remarked. "Well wait until you see the festivities this afternoon," she replied without explaining herself. A knock on the courtyard door startled Christine, as people seldom used the door from that side. She opened it to see a tall, elderly man.

"I'm Judge Seth," the man said. "I'm here to see Juan. Hello, Georgia." Her face lit up, visibly happy to see an old friend.

He sat down on the couch next to her, taking her hand. Christine left the room to find Hamilton. Pita told her he was in his office so Christine gave her the information that Judge Seth had arrived and, curious, asked what was going on. "I don't know, Christine. Nobody ever tells me anything." She and Candelaria appeared to be getting ready to leave for Abiquiu.

Christine returned to O'Keeffe's room when she heard Hamilton's voice as he emerged from his office. Judge Seth joined Hamilton and the others in the living room. Soon they were engaged in animated talk, discussing the provisions of the will.

That day Christine left at three P.M. Judge Seth had

already left, to Georgia's protests. "I'll have to come back," he told her, adding that there were some papers he had to get. "That's not good enough," she had responded, laughing. The Santa Fe lawyer had left earlier. As Christine was driving off, a woman drove in swiftly, followed closely by the lawyer in another car.

Christine was off the schedule for that afternoon and the whole of the next day. When she returned at seven A.M. the following morning, O'Keeffe was still asleep and, once again, reluctant to rise. Christine was alarmed at her disposition when she finally got up. For an hour she was very sour, scowling, snapping at Christine, calling her by other names. Christine had been worried about her for about ten days, having recorded in the nursing log that she seemed less coherent, more detached and tired than usual, more confused. Her posture was slumped, she showed a lack of appetite. On this day she tightly clenched her handkerchief.

After watching her, Christine asked if she wouldn't like to lie down again to relax, but O'Keeffe said nothing, as though she hadn't heard, her lower lip protruding more. Worried and mystified, Christine asked her how the day before had gone.

"I could've done without it," O'Keeffe said. She remained essentially silent the rest of the morning, and never mentioned the day again.

Twenty-two

On that last day of mine in the Santa Fe house, all I had time for was to hug her and to tell her that I loved her. An ideal situation would have been to be able to go back and visit. But what was a big surprise to me when I left was that I didn't miss her. And the reason why was because she was still with me. I didn't feel separated from her. It had nothing to do with my being there physically. I knew she had been present in the process of what I gave her and what she gave me. She knew it and that was all that mattered. What benefit there was from what I had done, she had received.

We had talked before about my possibly leaving, and she had asked me not to. And the morning I quit I told her about his grabbing me, which was only a small part of why I was leaving. We had talked about conditions before and she had understood. In July we had talked about it and she had told me to try and stand up against him: "People think we are vain if we tell them what's what. Well, I suppose they'll just have to think that way but I don't think they are making very much

197

Miss O'Keeffe

sense, do you? Just tell Juan what's what. Don't you just tell people what's what?"

I was well aware of her reputation for doing just that. I recall laughing. "It gets me in trouble sometimes, Georgia!"

In late 1985 I took a job at a bed and breakfast inn, while getting ready for an exhibit of my drawings. I took the job thinking it would be less abrasive to my spirit than many other jobs since it was a warm and familiar place to me. My sons and I had many happy memories of the house after having lived there several years before it was an inn.

I was setting the table for breakfast in that large Queen Anne house, when the announcer over the radio on the mantel-piece said, "Georgia O'Keeffe . . ." My eyes instantly filled and my hands shook. I didn't need to hear the rest of the sentence to know what had happened. I stared through my tears, smiling slightly, for what I was feeling was so gentle. And I just stared at the silverware, attempting to make sense of the difference between a fork and a spoon, momentarily trying to figure out what to do with them, wondering what they were for while the voice on the radio went on, "artist . . . died today in St. Vincent's Hospital . . ."

My eyes blurred. I remember everything turning into bright watery patches; I wiped my eyes and continued to place the silver on the table deliberately, consciously, cleared suddenly by a memory of Georgia telling me we have a responsibility not

to bother other people's eyes. It seemed to me then that it was very important to set that table properly.

The date was March 6, 1986.

The telephone rang. It was my friend Carol Sarkisian, who had known Georgia for many years and who had taken care of her after I left. She asked, "Did you hear about Georgia?" We began to cry and spoke slowly and softly about this woman we loved and had spent so much time with, learned from, learned about being a woman from, about being artists from. Carol made the comment that she felt pain for all the women who had taken care of Georgia because she knew how much we had all cared for her. That was one of Carol's first reactions and I was very touched by it.

We spoke of others we felt would be in sorrow, of Pita and Candelaria, and we spoke of the rare gift of having cared for Georgia, blessed by our contact with her. We wept and couldn't continue on the phone. I went outside and saw that the wind was pulling through the New Mexico sky. It was as if her spirit were moving across her land.

It has always fascinated me that we are visible in only one place, occupying an identifiable space—our body—and physically, when we die we are only missing from that one space. We never were in all the others, so are we missing from anywhere else? I felt an inevitable human ache within me but was also aware, once again, that I didn't feel separated from her.

Miss O'Keeffe

Whatever pain I felt then was assuaged by the sure knowledge that she had given us many treasures and was very tired, very ready.

Later that evening, as our side of the planet turned away from the sun and was no longer lit or warmed by it, I thought how odd it was to lose the sun's light but to still be lit and warmed by O'Keeffe's spirit and presence, this now unseen, supposedly fragile creature.

There was no public funeral. Carol told me that her ashes were strewn at Ghost Ranch.

Friends called me to tell me that they were sorry, as though it were my loss, which surprised me. They knew that I cared so much for her. The only call I got from the staff was from Pita.

For about a year and a half towards the end, Georgia's health had been failing. I saw the beginning of that. Carol said Georgia was confined to bed much of the time; that must have been disheartening to one such as Miss O'Keeffe.

I felt sad to think that Georgia had to end her days in a house that had no sense of ritual to it, no sacredness to it. I had often pictured her dying at Ghost Ranch.

When I was young, trying to make sense of life, just beginning to grasp the inevitability of change and movement, I stood by a pond and wondered, "Isn't anything stable? Can nothing be counted on?" Just then I saw in the pond the reflection of a large tree, strong and imposing, solid, the essence

of endurance. Taking solace from it I thought, "The earth, the trees, there is stability!" But just then a breeze or a pebble or a frog disturbed the water and shattered the illusion.

I turned from the pond, stunned, to see the real tree standing rooted and still, and since then I have never seen trees the same way, nor the earth nor water nor humans.

With that same fascination I said goodbye to Georgia and acknowledged her death, for I suspect that she is rooted where she lived, and lives, reflected in the hills she painted.

Miss O'Keeffe

Designed by Milenda Nan Ok Lee
Typography in Garamond #3
by Tseng Information Systems, Inc.
Printed by Thomson-Shore, Inc.
Printed in the U.S.A.